Photography & the art of seeing

Books by Freeman Patterson Photography for the joy of it Photography and the art of seeing Photography of natural things Garden of the Gods

Photography & the art of seeing

FREEMAN PATTERSON

Copyright © 1985 by Key Porter Books Limited

All rights reserved. No part of this work covered by the copyrights hereon may be reproduced or used in any form or by any means—graphic, electronic or mechanical, including photocopying, recording, taping or information storage and retrieval systems—without the prior written permission of the publisher.

Key Porter Books 70 The Esplanade Toronto, Ontario Canada M5E 1R2

Design by Keith Scott Editing by Susan Kiil Typesetting by Howarth & Smith Limited Colour separations by Herzig Somerville Limited Printed by Friesen Printers All photographs are by the author

Canadian Cataloguing in Publication Data

Patterson, Freeman, 1937– Photography and the art of seeing

ISBN 0-919493-81-5

1. Photography, Artistic. I. Title.

TR145.P378 1985 770'.1'1 C85-099208-7

85 86 87 10 9 8 7 6 5 4 Printed and bound in Canada

Preface

Seeing, in the finest and broadest sense, means using your senses, your intellect, and your emotions. It means encountering your subject matter with your whole being. It means looking beyond the labels of things and discovering the remarkable world around you. This book is for people who want to see, whether they are photographers or not.

If we look at something that might seem mundane, such as a gravel pit, we are first aware of what it expresses in only the most general sense: destruction, desolation, loneliness, timelessness. This message or theme is expressed in the sum of the features of our subject matter. It is only later that we observe the details, their shapes, textures and colours, and their inherent design.

The photographer best expresses a theme by using good composition, or visual design, to support the inherent design of the subject matter. However, when the photographer tries to codify the principles of visual design, or merely follows rules of composition, he is likely to inhibit spontaneity and creativity. The photographer who becomes familiar with the principles of visual design, and who puts expression before technique, will develop intuition for good design, sensing and responding to the expressive qualities of the subject matter.

The purpose of this book is to help you improve your visual thinking — to observe more accurately, to develop your imagination, and to express a theme or subject more effectively with photographs. The exercises in "relaxed attentiveness" will help you to observe things more exactly by first concentrating on clearing your mind and learning how to switch yourself off, so you can turn your subject matter on. Letting go of yourself is an essential precondition of real seeing. The exercises in "thinking sideways" will help you to break out of old habits that control the way you see, and photograph. The exercises in imagining will help you discover powers of imagination you didn't know you had. You may find yourself abandoning your normal premises and going on a search for new ones. You may forget about the pictures you have

been making and start thinking about the hundreds you have yet to make. Once you have tried these exercises, you may find yourself, as I have, seeing things as you have never seen them before!

Good seeing doesn't ensure good photographs, but good photographic expression is impossible without it. The art of seeing is the art of photography.

Freeman Patterson Shampers' Bluff New Brunswick June, 1979

Contents

Preface 5
Barriers to seeing 9

I LEARNING TO OBSERVE 25

Thinking sideways 27

Thinking sideways • Exercises in thinking sideways • Chance • Exercises in chance • Familiar things • Exercises in seeing familiar things • Being flexible

Relaxed attentiveness 38
Relaxed attentiveness • Exercises in relaxed attentiveness

II LEARNING TO IMAGINE 55

Imagining 56
The mind's eye • Exercising your imagination

Abstracting and selecting 61
Abstracting and selecting Exercises in abstracting and selecting

III LEARNING TO EXPRESS 65

The challenge of expression 66

Expression · Exercises in expression · Expression in subject matter · Subject matter and you

Unique properties of photography 85

How a camera sees space 89

Thinking about visual design 103

Elements of visual design: form 105 Light · Light and shape · Light and texture · Light and line · Light and perspective · Perspective and other variables · Another look at form

Elements of visual design: colour 113
Colour and emotion · Colour and time · Colour as a
thing-in-itself · Colour and composition

Principles of visual design 119
Dynamic simplicity · Achieving dynamic simplicity: dominance, balance, proportion, pattern and rhythm, deformation

Working with visual design 125
Centre of interest · Base · Filling the picture space ·
Frames and windows · Lack of perspective · Amputation ·
True colour · Correct exposure · Symbolism

Photography and the art of seeing 145

Acknowledgements 155

About the author 156

Barriers to seeing

On those frosty mornings when I grab my camera and tripod, and head out into the meadow behind my house, I quickly forget about me. I stop thinking about what I'll do with the photographs, or about self-fulfilment, and lose myself in the sheer magic of rainbows in the grass; in the multi-coloured prisms of back-lighted crystals. I am lost in a world of glittering lights and dancing colours. I experience myself in what I see, and the result is a tremendous exuberance which helps me make the best use of my camera, and which lasts long after the frost has melted.

Letting go of self is an essential precondition to real seeing. When you let go of yourself, you abandon any preconceptions about the subject matter that might cramp you into photographing in a certain, predetermined way. As long as you are worried about whether or not you will be able to make good pictures, or are concerned about enjoying yourself, you are unlikely either to make the best photographs you can or to experience the joy of photography to the fullest. But when you let go, new conceptions arise from your direct experience of the subject matter, and new ideas and feelings will guide you as you make pictures.

Preoccupation with self is the greatest barrier to seeing, and the hardest one to break. You may be worrying about your job, or the kids, or other responsibilities, or you may be uneasy about your ability to handle a new lens or to calculate exposure. There always seems to be something standing in the way of real freedom. Frederick Franck in *The Zen of Seeing* calls this the "Me cramp"; too much self-concern blocks direct experience of things outside yourself. Sometimes the only way to

overcome the cramp is through practice. You cannot relax your mind and body separately – they are too much a part of each other. In order to get the tightness and tenseness out of your body, you have to empty your mind. It is like the connection between wind and water. The waves will not subside as long as the wind is blowing. Relaxing is the act of stopping the mental winds, so your body will be still.

Another barrier to seeing is the mass of stimuli surrounding us. We are so bombarded with visual and other stimuli that we must block out most of them in order to cope. Instead of seeing everything, we select a few stimuli and organize these. Then, once we have achieved order in our lives, we stick with the realities we have established. We seldom try to rediscover the possible value of ignored stimuli, and are reluctant to do so as long as the old ones still seem to be working. We develop a tunnel vision, which gives us a clear view of the rut ahead of us, but prevents us from seeing the world around us.

A third major sight barrier is the labelling that results from familiarity. It was Monet, the painter, who said that in order to see we must forget the name of the thing we are looking at. When we are children we think primarily in pictures, not in words. But this approach is played down when we go to school. The basic analytical skills (reading, writing, and arithmetic) are impressed upon us as being more important than the appreciation of direct sensory experience, so we come to depend less and less on the part of the brain that encourages visual thinking. By Grades Three or Four, many of us no longer regard painting or drawing as being very important; we stop visualizing things freely, and put word labels on them instead. This pattern becomes so firmly established that, by adolescence, we hasten to catalogue everything we see. We rule out visual exploration, and seldom discover the myriad facets of each object. As Frederick Franck so aptly expresses it, "By these labels we recognize everything, and no longer see anything. We know the labels on the bottles, but never taste the wine."

If you look at a fern and merely say, "Yes, that's a fern," you may not be seeing past the old, familiar label of its name. But if you really *see* a fern, you will notice triangularity, individual leaf fibres, various shades of green, its sway and dance before the wind. If you put your eyes close

to the fern, so close that you cannot focus on the plant at all, but only on objects beyond it, the fern will become a nebulous green haze which drifts across the background scene. You will have found dimensions and hidden beauty not included in the usual definition of a fern, while learning for yourself the difference between looking and seeing.

In viewing a photographer's work, do not let labels like "She's a portrait photographer" blind you to a beautiful landscape that she has made. Always try to understand the symbolic content of the photograph, or the meaning that the subject matter may have for the photographer.

Have you ever noticed, on returning from a holiday, your increased sensitivity to the details of your home? You glance around when you step in the door, and some things in the house may actually seem unfamiliar for a few minutes. You note that the living-room walls are more cream than ivory, that the English ivy looks spectacular in the west window. You even notice the evening light spilling across the little rug at the foot of the stairs, something you can't recall noticing before. But these moments pass quickly, familiarity is restored, everything is in its place; and you stop seeing once more.

How unfortunate it is that we don't respond with wonder every day to the magnificence of the English ivy. How sad that we don't see the light spilling across the little rug every evening. These sights are dismissed from mind and eye because they are so familiar, and their value as things-in-themselves goes unappreciated.

Where I live, people seldom notice the dandelions in the spring because there are so many of them. But, in southern Africa, a woman I know struggles to grow a little patch of dandelions in her garden. For her, dandelions are not familiar. On the other hand, she treats the colourful species of daisies which grow rampant in her area as too common, too familiar to be treasured.

A photographer who wants to *see*, a photographer who wants to make fine images, must recognize the value of the familiar. Your ability to see is not increased by the distance you put between yourself and your home. If you do not see what is all around you every day, what will you see when you go to Tangiers? The subject matter may be different, but unless you can get to the essence of the subject matter through keen

observation, and express it through your photographs, it doesn't matter how exotic your locale.

Even the camera itself can be a barrier to seeing, in at least two ways. Susan Sontag, in *On Photography*, describes the first one: "A way of certifying experience, taking photographs is also a way of refusing it – by limiting experience to a search for the photogenic, by converting experiences into an image, a souvenir." Making pictures can be a substitute for seeing and participating. The person who sees is involved, the person who looks is not.

The camera is also a sight barrier because it does not see as the human eye does. We see a scene or situation in terms of both our senses and our experience. When we look at a landscape, we observe and remember only a few dominant features — enough to give us an impression of the landscape, which is often all that we need. But since a camera has no experience, it cannot select, so it records everything in its field of view. Its memory is perfect. For our purposes, then, the main difference between a person and a camera is that a person abstracts, but a camera does not.

People are constantly abstracting. They do it without thinking. So when they use a camera, they are often surprised to find that the scene the camera saw is not what they saw or, more precisely, not what they thought they saw. A major challenge in using a camera is learning to control it (and other tools and techniques) in order to produce a picture that shows what you perceived.

Except for the optical differences between the camera and the human eye, all barriers to seeing are related to the first one — preoccupation with self. A good deal of our self-concern is a natural part of the responsibilities of feeding our families, looking after our health, and paying our bills. But all these things can be done without closing our eyes to the remarkable world around us.

Seeing, in the finest and broadest sense, means using your senses, your intellect, and your emotions. It means encountering your subject matter with your whole being. Good seeing doesn't ensure good photographs, but good photographic expression is impossible without it.

Good seeing begins with careful observation of what's around you. This tiny roadside meadow is in Alberta, close to several houses. It's quite remarkable as it is — and requires neither complicated composition nor exposure. Many nature subjects are most effective when you photograph them as they are, with special attention only to the camera position. It's seeing and evaluating the subject matter on its own merits that matters.

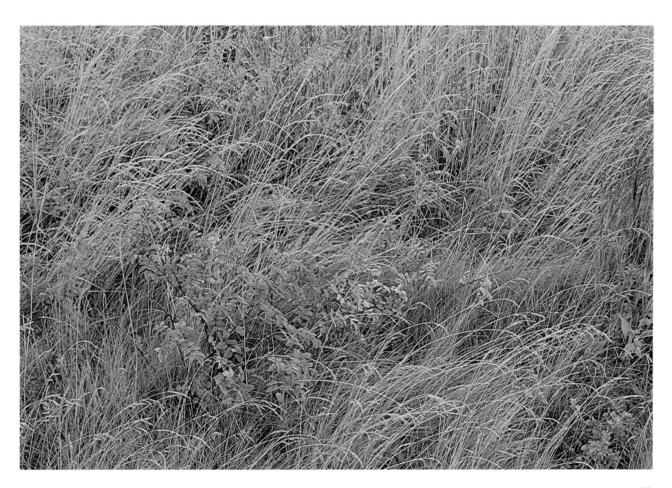

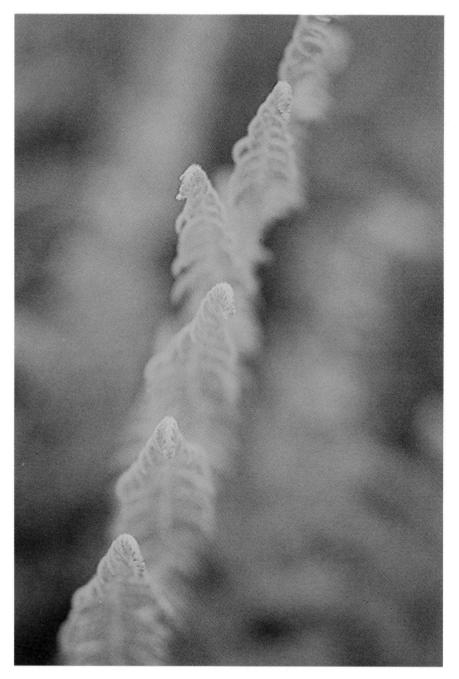

When is a fern not a fern? Any time you remove its label! You won't see this composition by merely looking at a clump of ferns. But by continually changing camera position, focus, and depth of field, you will stop looking – and begin to see – shapes and patterns you hadn't thought possible. By avoiding preconceived ideas and by deliberately exploring, you will be able to see ferns and all other subject matter in ways that you have never experienced before.

When you observe subject matter carefully, you may find that a story emerges. Your camera position and techniques should help to tell it. Here, hay-scented ferns emerge from the brown stalks of the previous year's growth. The granite rock behind them absorbs heat during the day and releases it during the night, warming the soil, and causing these fronds to grow much earlier than others farther away. Because the rock is crucial to the story, it must occupy a major portion of the picture space.

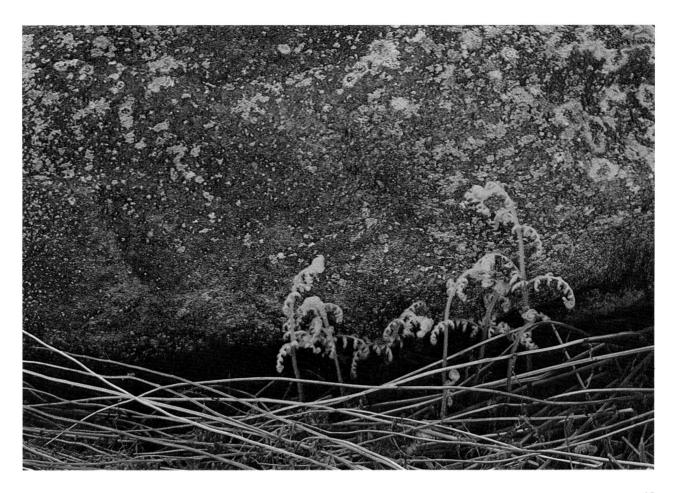

This photograph and the one opposite were made within moments of each other. While I used my 100mm macro lens for both pictures (plus two close-up lenses for the other one), other equipment would have been just as successful. To capture the prismatic effects caused by the back lighting on the frost crystals, I had to tilt the lens downward at approximately the same angle as the sun's rays. To enlarge the circles of colour, I had to use minimum depth of field, while focusing on a foreground object and throwing the background out of focus. The most minute change in camera position altered the arrangement of colours greatly, so I had to be careful but quick in deciding which effects to shoot, and which ones to ignore.

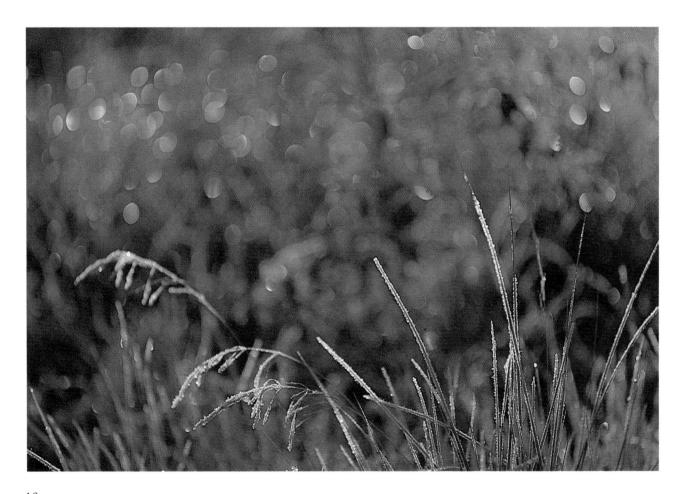

For me, moments like this are pure magic. I respond enthusiastically to the dance of hues and tones. In this situation I had only a few minutes to make the photographs I wanted before the sun melted the frost. So I had to work quickly; yet I was able to experience the sheer beauty of the subject matter as I photographed it. It's very important to be familiar with your equipment, so that when opportunities such as these arise, you don't have to fuss and worry, and lose precious time — and enjoyment.

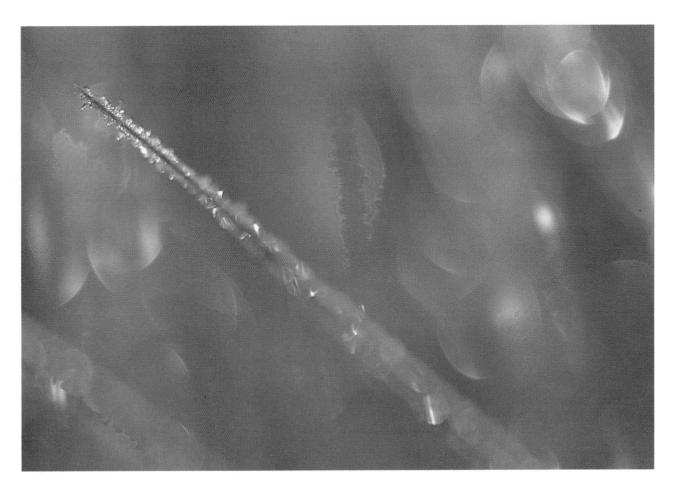

I wanted to capture a strong feeling of the discovery of beauty on this brisk autumn day. So, I stood in the middle of a maple bush and let coloured leaves cascade over my head and my camera. I set the telephoto lens at its widest aperture to narrow the depth of field, and focused on another bush a few metres away. The out-of-focus leaves formed a window through which I could peer. The oblique position of the opening in the leaves and the contrast of sharpness between foreground and background leaves make the lively hues seem even more dynamic.

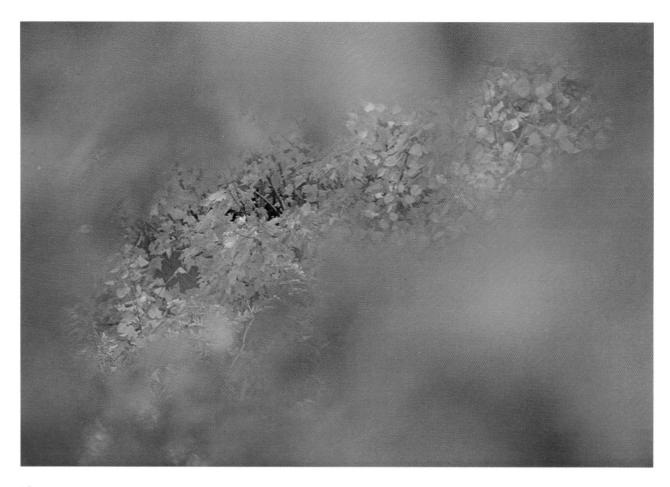

Good visual design in your photographs comes with careful observation. Because the forest is dead, the virtual absence of colour is the most evocative element in this photograph. The pallor and the repetition of the thin parallel lines produces a very strong static design. The oblique shaft of light in the upper right relieves possible monotony and suggests transition – the light tells us that the static quality will change. Notice the subtle repetition of the oblique line in the lower left. It provides an unobtrusive, secondary visual support that a photographer should always be looking for when composing a photograph.

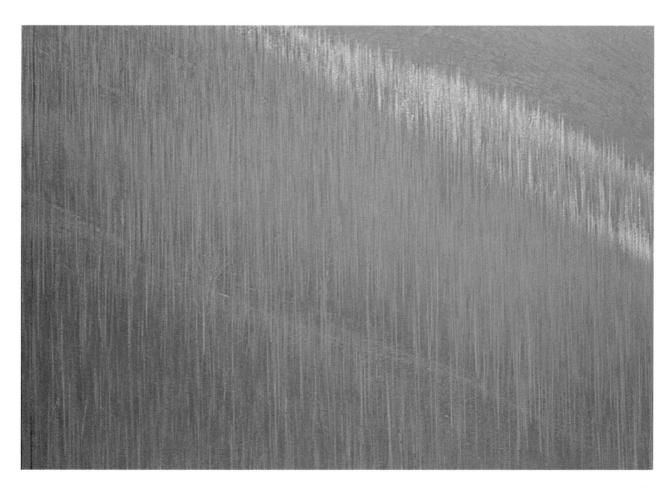

Often, the way we see is influenced by the symbolic power of the subject matter. Tombstones, of course, suggest death. But, in this photograph, the warm light that spotlights them symbolizes life and possible comfort. The result is a positive impression, rather than a negative one. For many people, the church also has symbolic value, suggesting emotional support and strength.

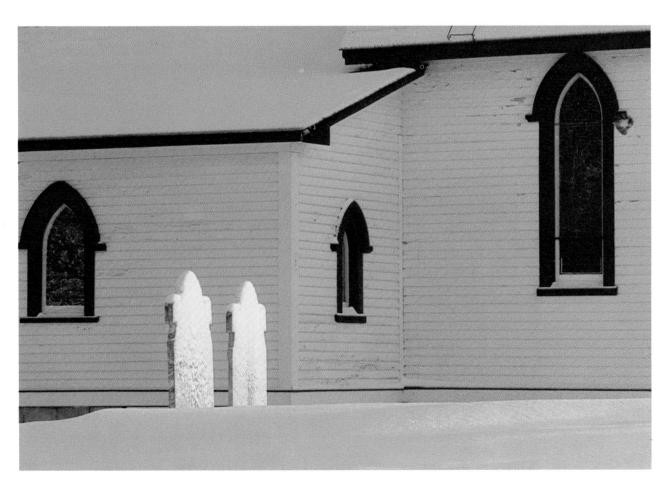

It's easy to zero in on a centre of interest and to overlook its surroundings. However, a small object in a large context often expresses the theme of a photograph more clearly than a single object that fills the frame. This rural Quebec winter scene is a good example. The effect of the photograph depends on keeping the centre of interest small and filling most of the picture area with large expanses of white space. Also, because the foreground fence and the background line do not join within the picture, but seem likely to meet eventually, movement is implied. The suggestion of movement is reinforced by the location and direction of the horse and sleigh. No other placement would be as effective.

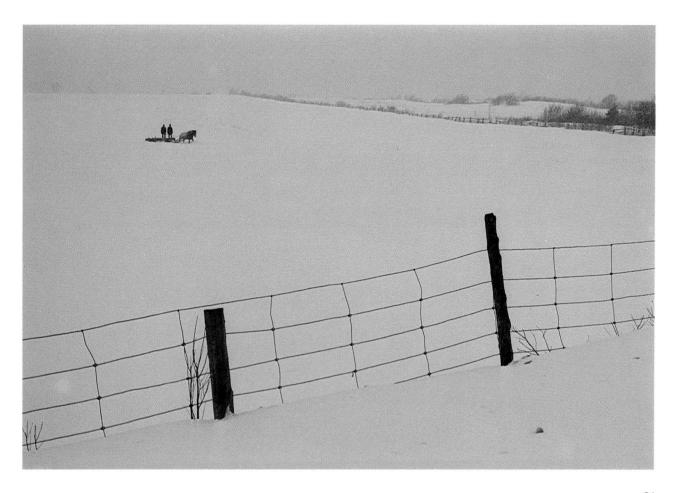

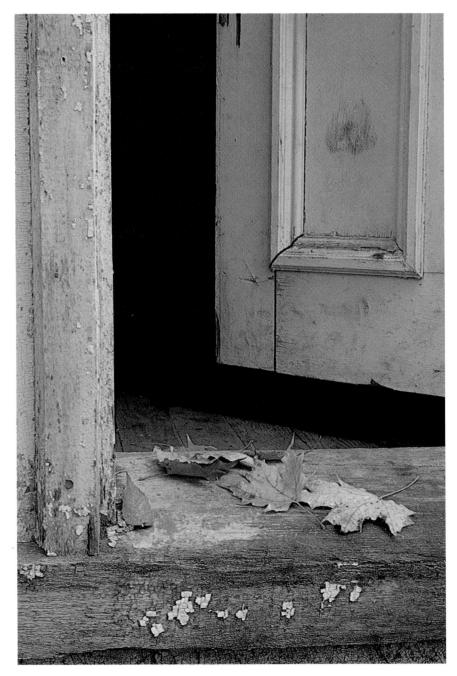

When we see a situation we want to photograph, we should ask some basic questions. What is the theme or subject. Abandonment, loneliness, a little sadness. What is the subject matter. Fallen leaves on the threshold, a swinging door, peeling paint. How does the subject matter express the subject. Through muted tones caused by soft, indirect lighting, through the limited presence of colour, through the symbolic power of autumn leaves and old, decaying wood. Try asking these questions the next time you make a photograph - in order to ensure that the theme is expressed well.

Familiar things offer excellent picture possibilities and a chance to exercise your imagination. A pile of boards behind my house reminded me of some sand dunes that I had photographed only three days earlier in an African desert. The similarities between the boards and the dunes helped me to remove the labels from both, and to realize that their expressive power was in their tones, shapes, lines, textures, and hues — the real subject matter of this photograph.

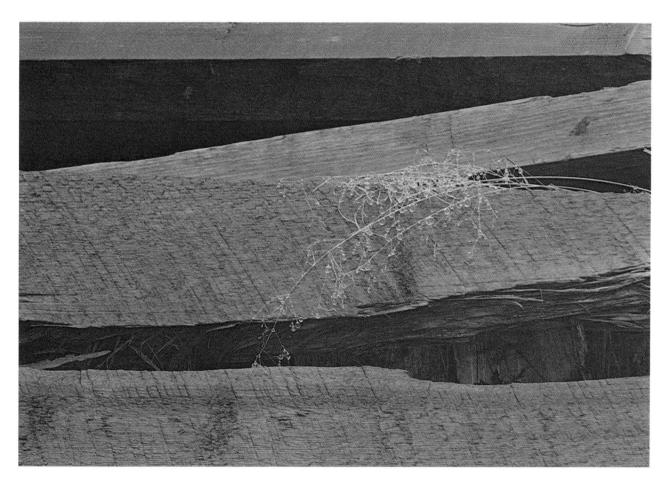

Notice the similarities between this photograph and the preceding one, despite the different subject matter. When you observe carefully, you begin to recognize visual elements that are common to all physical material. This is one key to developing an awareness of good visual design. You should examine not only photographs, but also paintings, batiks, drawings, and so on, to see how other artists use the basic visual elements, and to stimulate your own imagination.

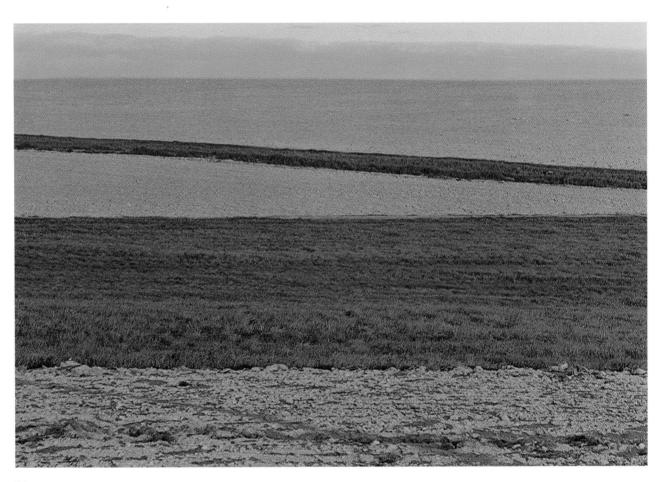

Learning to observe

People think with different kinds of symbols, such as words, sounds, and pictures. None is more important than pictures, or visual images. When a runner begins a race, he visualizes the distance he has to cover to reach his goal. When a dressmaker begins to sew, she visualizes a finished dress. When a farmer plants seeds in the spring, he visualizes his garden at harvest time. When a photographer observes objects, scenes, and events, he or she tries to visualize how best to record them on film.

We think with three kinds of visual images – the kind we observe (physical objects), the kind we imagine (visual ideas and dreams), and the kind we create (a sketch, painting, or photograph). While some people are better at thinking with one kind of image than with others, the best visual thinkers are able to move easily between these modes, and even to use all of them at the same time.

The purpose of this book is to help you improve your visual thinking in all three ways — to observe more accurately, to develop your imagination, and to express a theme or subject more effectively with pictures.

Let's start with observing. It can be either casual or "focused." Focused observation is not easy to achieve, but it should be every photographer's goal. It means simply examining things in detail and believing they are important in their own right. Here are two different approaches to assist you in developing your powers of focused observation.

The first one, "thinking sideways," is especially useful to photographers who want to break out of old habits. It is simply a matter of building up a mass of visual information about your subject matter by observing it from many points of view. Photographic exercises in thinking sideways are a serious, but entertaining, business.

The second approach, "relaxed attentiveness," helps you to observe things more exactly by concentrating on clearing your mind. As your powers of observation grow, so will your imagination, and you will find yourself getting closer to your goal of making pictures that effectively express the subject and your response to it.

Thinking sideways

I have always thought of spiders' webs covered with dewdrops as celestial jewellery, although until a few years ago I photographed them only as if they were architectural forms. I would position my tripod and camera at an appropriate distance, usually filling the picture space with a web in order to show its lines and shape, and use maximum depth of field to ensure sharpness of linear detail. I guess I thought this was the way I should do it, or, perhaps, the way viewers wanted to see it. I had accepted this way of seeing webs as my own.

One autumn morning, when webs were hanging thick in the wet bushes and grasses behind my house, I awakened to the realization that all my photographs of spiders' webs looked the same. They were entirely documentary. Beautiful, yes! Expressive of how webs make me feel, no! There was nothing wrong with what I was doing, but a lot wrong with what I was not doing, so I decided to look at webs in ways that I had never considered before. I didn't know what I was going to do, but simply decided to follow each new idea that occurred to me.

To begin, I placed my camera to one side of a web and focused on the nearest edge. I also switched from maximum to minimum depth of field. Instead of architecture, I saw jewels – at last I was seeing a web the way I felt about it. This was the beginning of a significant change. It was the start of what has become, for me, a kind of visual love affair with spiders' webs.

Next, I crawled underneath a web and shot up at it (no easy matter, I discovered, after destroying several webs!). Later, I hauled my close-up

equipment out of the closet — extension tubes, close-up lenses, and what-have-you, and started using them in combinations that I'd never tried before. I made no effort to preconceive the kind of pictures I could make as I selected, for example, an 80-200mm zoom lens to be used with an extension tube behind it and a close-up lens in front. I simply put the equipment together, went out, and started crawling through the grass. I overexposed and underexposed. I put everything in focus, then threw everything out of focus. The fact that many of the photographs might be visual disasters didn't concern me. I wasn't after masterpieces; I was looking for new starting points. I wasn't seeking solutions to old problems, but welcoming new ones.

Webs are so beautiful in their own right that they had kept me from examining them carefully, and especially from photographing them in a personal way. This can happen if you become so captivated by the first impressions of your favourite subject matter that you photograph only its surface appearance. After photographing it again and again in the same way, and seeing the same results, you become bored and may drop it altogether. Remember to explore the subject matter and your response to it.

When you think sideways you will find new ways to see your subject matter, and you will stumble upon discoveries and happy accidents. Abandon your normal premises, and go on a search for new ones. Instead of only trying to improve your present photographic approaches and techniques, consider approaches and techniques you've never tried. Forget about the web pictures you've been making. Think about the ones you have yet to make!

Most people reason deductively much of the time and most photographers see that way. We have a premise or dominant idea, whether or not it is consciously determined, and we proceed along a line of thought that develops logically the implications of that idea. Eventually, we reach a conclusion. It's a closed process. Seldom do we look sideways, that is, search for other premises or new beginnings. We avoid introducing new factors, technical or emotional, into our photography for fear that we won't be able to control them.

A good way to break the grip of an idea that controls the way you see

and photograph, is to pretend that it doesn't exist. You must break the rules.

EXERCISES IN THINKING SIDEWAYS

Draw up a list of some photographic rules; then go out and break them.

A sample list might look like this.

Rule 1. Always hold your camera steady.

Rule 2. Be sure the centre of interest is in sharp focus.

Rule 3. Follow your light meter.

Then, take this list and, with various subjects, make pictures in direct contradiction to the rules.

Breaking Rule 1

Jump up and down in the forest, and press the shutter release as you jump.

Run as fast as you can toward a parked car, and press the shutter release as you run.

Make sure the strap on your camera is absolutely secure. Set the shutter at a slow speed, and activate the self-timer. Then, swing your camera in circles, or back and forth, until the shutter has released.

Breaking Rule 2

Make a series of pictures in which the main subject matter is clearly out of focus, but other things are sharp.

Shoot a sunset, a flower, and the surface of back-lighted water, entirely out of focus.

Breaking Rule 3

After you have read your light meter, make a series of photographs with five different subjects in which you overexpose each one the equivalent of three full f/ stops. Overexpose even more if you are using black-and-white film. Then repeat the exercise while underexposing three full f/ stops.

When you look at the resulting slides or negatives, you must view them in the same frame of mind as you took them. If you don't, you may reject them all as disasters. Keep on behaving as if the old dominant ideas no longer exist. Remember, the whole idea of these exercises is to break away from what you've been doing.

By jumping up and down in the woods or by moving your camera up and down while pressing the shutter release, you may have stretched the trunks of trees into long, tall vertical shapes, creating a bamboo-like effect. The photograph on page 46 was made in this way. Perhaps you are not pleased with your photographs because of certain details like distracting highlights in the upper corners; but such problems can be controlled in future by changing your movements or choosing another spot. The main point, however, is that you now have a new idea, something you discovered only by going directly against a rule which you thought you should never break. Take this new idea and try to develop and refine it.

By rushing toward the car as you released the shutter, you may have made a shot in which the car seems to explode with motion. By overexposing three stops in a forest, you probably washed out all detail in the trees, but still retained the occasional line of a tree — producing delicate new shapes. Think up more exercises for yourself, and try them. The results may seem chaotic, but all the time your mind will be retaining information to help you sort things out and evaluate the new effects when you see your photographs.

The first time you look at your results, be sure to give your emotions free rein. Don't be afraid to exclaim "Hey, I like this!", even if the picture seems all wrong according to your old standards. Your emotional reaction is every bit as important as your rational response. Look first for pictures that you like or dislike strongly. Then, put your logic to work. Analyse *why* you respond the way you do. What effects in the pictures do you like that you can now employ deliberately when you make more photographs?

CHANCE

One thing you'll notice, when you view your results, is a number of happy accidents. You'll probably find several if you have been generous in your use of film. It's false economy to be stingy with film when you are experimenting with new ideas, so don't limit yourself to a few

photographs; make at least ten pictures for each exercise. Give many happy accidents a chance to happen.

Photographers who want to see in new ways should be sensitive to chance. They should encourage and cultivate it, because it is only through chance that many new opportunities for visual development will ever occur. The camera operates so swiftly that you can capture, as no other artist can, occurrences that happen by chance, or that you have caused to happen by exercises in thinking sideways. Even when you are not completely satisfied with the results, they can be instructive. They may suggest a new idea or technique which you will want to develop.

A friend of mine, who teaches photography and natural history, has a remarkable knowledge of small plants, insects, stones, and other natural objects, and of how they all fit together in nature's scheme of things. She frequently uses an exercise that depends largely on chance. After a brief talk with her students about the natural environment of the area in which they are meeting, my friend gives each student a wire hoop (which she has made by bending a coat-hanger into a circle). Everyone tosses a hoop through the air and the space it encloses when it lands becomes each student's area for studying nature and making photographs.

Often a hoop lands in what first appears to be a most unpromising spot, devoid of any subject matter worth studying or photographing — that is, until my friend peers into the circle. Within a couple of minutes, she is able to make each student feel lucky that his hoop fell where it did. Soon everybody is busy making notes on what is happening in his little circle — and making pictures.

Only in retrospect do the students see the value of chance. If they had been asked to choose a spot rather than toss a hoop, every one of them would have tried to select a location based on their preconceptions of suitable subject material. And they would have missed the experience of seeing and photographing things they would normally overlook.

Try the hoop exercise yourself. Then try the two exercises which follow. Why not ask other photographers to do the exercises at the same time? It's useful to compare the results.

1. Pick up your camera, a standard lens, and your tripod, and go to

the front door of your home. Take 19 steps (or any other arbitrarily predetermined number) in any direction. Mark the spot. Take seven more steps from the spot you marked. The seven steps from your original stopping point form the radius of a circle, in which you should proceed to shoot an entire 20-exposure film. Don't set a limit of two or three pictures, because that will not be enough to start you seeing. You should feel desperation during this exercise. You will only start to make visual breakthroughs when you have exhausted the obvious picture possibilities. If you want to challenge yourself even more, shoot a roll of 36-exposures instead.

2. Have somebody – anybody but yourself – choose three seemingly unrelated objects for you to photograph together. Perhaps you'll find yourself facing a stool, a wig, and a bunch of onions, or a bowl, a tennis racquet, and a handful of grass. Don't expect masterpieces; expect a struggle. Minimum requirement: a roll of twenty pictures. A valuable exercise!

FAMILIAR THINGS

The next three exercises will keep your spirit of discovery alive, make you more aware of familiar things, and help to break the grip of fixed ways of seeing and photographing.

- 1. Lock yourself in your bathroom with a camera, a tripod, and a standard lens. Give yourself twenty minutes to make ten pictures. This is an exercise that I have tried with several students the resulting slide shows have been both hilarious and instructive, and the variety of pictures amazing.
- 2. Put a wide-angle or standard lens on your camera, load the camera with a 20-exposure roll of film, and put it beside your bed. As soon as you wake in the morning, shoot at least five photographs from the prone position, and at least five more while sitting on the edge of the bed. Shoot the remaining ten frames before you reach the bathroom. Don't worry much about composition, but simply shoot the things that catch your eye you might even include yourself or part of yourself in the photographs. This exercise always brings loud groans when I suggest it. The idea, however, is sound enough to examine visually the everyday

routine of your life, one so familiar to you that you have rejected it as bereft of important visual content. You will learn about yourself, both during the shooting and on viewing the pictures later. (If morning is not suitable for you, select another time in your daily routine.)

3. If you have a pet, make a note of how high its eyes are when it is walking. Make a series of twenty pictures, holding the camera at that height, preferably in surroundings that the animal frequents. The resulting pictures make an interesting series of prints or a slide show – showing your home, or the backyard, or a forest, from your pet's point of view. The exercise may help you to understand your pet's perception of its environment a little better, and your show may stretch your friends' understanding as well. I like trying this exercise from time to time – using an ultraviolet filter to protect the lens from my two dogs, who occasionally sniff the lens.

Try reviewing these exercises with a group of photographers. Photograph individually, but get together to view the results. It is very helpful to ask a photographer from outside of the group who can appreciate new approaches, to edit the slides and make up a show from the pictures submitted for each exercise. There will be an overabundance of photographs if several people are working on the same exercises, but not all of the photographs have to be shown. The editor must be instructed to select photographs that show evidence of new ideas or unusual departures, regardless of their technical merit, and also to show a minimum number of photographs from each person who completed the exercises. You may want to give the boxes of slides to the editor unopened, with the makers of the slides unidentified, except perhaps by a number or a mark, so the editor and viewers will be aware of individual approaches.

The presentation is likely to be astonishing in its diversity, hilarious in its near misses and unusual viewpoints, and tremendously stimulating. The excitement often generates such enthusiasm that the photographers can hardly wait for the last picture to be shown, so they can immediately resume the exercises – this time using the new ideas and approaches they have learned from the work of others in the group.

One word of caution about trying these exercises in a group. Don't turn

them into competitions. Let the incentive be the new ideas they will produce. Prizes and honours seldom stimulate creativity. Sometimes the person who does the least imaginative work overall produces the single most brilliant photograph, and that in itself is sufficient cause for rejoicing. Sometimes a participant feels that all of his own pictures are disasters, but having done the exercises along with everybody else, he is able to appreciate somebody else's successful approach, and perhaps later develops techniques to adapt it or even improve upon it. Sometimes a photographer will discover a remarkable affinity with certain subject matter or reveal a special talent which has never been tapped. These are the rewards for doing the exercises.

It is essential that you shoot pictures again before much time passes. The things you have learned from the exercises in thinking sideways will be reinforced most effectively only if they are used again soon. If you are looking forward to a weekend of shooting autumn colours, try some of these exercises in time to get the results back before you head into the woods. Try the exercises again to capture the autumn colour and mood. Then you can use your new approaches with confidence in other situations which are very special to you.

BEING FLEXIBLE

Thinking sideways helps you not only to keep out of photographic ruts, but also to see subject matter you may have overlooked or not observed carefully. It enlarges your world.

If you cultivate flexible thinking in your photography, you 1/ will recognize that rules, formulas, or any other dominant ideas can become obstacles to seeing rather than aids to better vision, 2/ won't worry about being logical all the time, because logic is only a way of developing ideas or viewpoints already acquired, 3/ will actively search for new or different ways of looking at things, and will shift your point of view when you come up against a problem that seems insoluble, 4/ will welcome chance, realizing that it can help to stimulate completely new ways of seeing and using a camera.

Thinking sideways is seeing a series of images of your subject that you

eventually piece together to get a complete perspective. It is walking around a barn to photograph it from every angle, so that you will have a good idea of what the entire structure looks like, rather than shooting the barn over and over again from the same spot.

Thinking sideways should precede thinking logically. Until you look at the barn from every viewpoint, you won't know whether or not you have discovered the best camera position. If you stay in one place from the outset, all you can ever hope to do is improve the pictures you make from that viewpoint – which may not be the best one.

You can practise thinking sideways at any time — not just when you make photographs. Once you start, you will want to keep it up, not only because it's so much fun, but also because you will quickly come to recognize the benefits. To help you get started, here are a dozen different photographic situations. In each example, the first statement is provided by a traditional thinker, and the second by a person who thinks sideways.

Traditional thinker: How can I avoid lens flare when I point my camera directly at the sun?

Sideways thinker: How can I use lens flare to improve my photographs?

Traditional: The picture space is only half filled. I must move closer to my centre of interest in order to show it more clearly and to help fill the empty space.

Sideways: The picture space is only half empty. I could try moving farther away from my centre of interest in order to show more of the environment and give a greater sense of space.

Traditional: The picture is too cluttered. I should remove all the less important elements.

Sideways: The picture is rich in detail. I should organize the less important elements around the centre of interest.

Traditional: There's no point in photographing the sand dunes today, because the sun isn't shining and there won't be any shadows. Sideways: I've never seen sand dunes photographed on a cloudy day, so I think I'll go out and see what I can do.

Traditional: I can't make any more pictures today, because my light meter has stopped working.

Sideways: My light meter has stopped working, so I wonder what kinds of results I am going to get. Perhaps I'll learn something when I see my pictures, even if most of them are underexposed or overexposed.

Traditional: I mind the cold weather so much, I don't think I'll make any pictures today.

Sideways: I mind the cold weather so much, I think I'll make pictures indoors today.

Traditional: The mushroom in this picture is damaged, which detracts from the pictorial quality. I must always try to find a specimen in perfect condition.

Sideways: The mushroom in this picture is damaged. It looks as if a squirrel had taken a bite out of it, which adds to the nature story.

Traditional: I came here to photograph wild flowers, but there is so much litter around that I may as well give up.

Sideways: I came here to photograph wild flowers, but there's so much litter around that I'm going to make an essay on pollution.

Traditional: I have been cataloguing my slides for several years, but I never seem to get caught up. My recent slides are always mixed up, and I can never find the ones I want.

Sideways: I have been cataloguing my slides for several years. I always code my new slides as soon as I receive them, so they won't get mixed up. Some day I'll get around to cataloguing my early work.

Traditional: I've finished preparing my audio-visual presentation, but I had such a difficult time combining the music and the script on tape that I didn't get any sleep last night.

Sideways: I've finished preparing my audio-visual presentation, but I had such a difficult time combining the music and the script that I decided to give my talk "live" and tape only the music. I had a good sleep last night.

Traditional: My dog just chewed on a box of slides. What a mess! His

teeth scraped the emulsion off several slides. Look at the blue and white lines! The slides are ruined.

Sideways: My dog just chewed on a box of slides. Several good ones have been destroyed, but these ones with the blue and white lines look interesting. Maybe I should experiment with a needle and some old slides to see if I can learn to etch lines on film for special effects.

Traditional: My tripod is too large for my suitcase, so I guess I'll buy a smaller tripod.

Sideways: My suitcase is too small for my tripod. Maybe I'll buy a larger suitcase!

Relaxed attentiveness

When did you last lean back in your easy chair and contemplate the patterns of light on the ceiling, rather than pick up a newspaper or turn on your television set? When did you look thoughtfully at the butter melting on your morning toast? When did you stop to examine the structure of a cabbage, as you bisected it for cooking?

In photography, observing is the first and most important skill we have to learn. Learning to observe requires us to set time aside to "see" familiar things. But, even if we take the time, we may find it difficult to observe carefully because we are tense and preoccupied with other things.

The first step in learning any skill is to relax. As long as you are worried, tense, or concerned about success, you are thinking about yourself – not about the skill you want to acquire.

The second step is to be able to pay attention to somebody or something else. The trick is to learn *how* to switch yourself off, so you can switch your subject matter on. You have to "let go." Effective photographic expression depends on it.

Here are some suggestions for developing an attitude of relaxed attentiveness. They are meant especially for photographers who have regular jobs — teaching, managing a home, driving a bus — people who have only limited time for photography, and find it difficult to move easily from working to picture-making; but they are also for people who have more time available for developing their photographic skills.

Preparation: 1/ Set aside a minimum of three 45-minute periods this week for making pictures. Note the times on your calendar. 2/ Assemble your basic photographic equipment — buy your film, load your camera, put it on your tripod, attach the cable release, and set out an extra roll of film. When everything is ready, put it in a corner or a closet for when you want to use it. 3/ Choose something around your home that you want to photograph.

First week: For each of the 45-minute periods, go to the most comfortable chair in your home. (Avoid your bed; the idea is to relax, not go to sleep.) Sit down and lie back. Close your eyes. Gradually start to breathe more deeply. Relax your muscles until your body is completely limp. Some people find it easier to relax bit by bit — concentrating on the legs first, then the arms, the shoulders, the neck, and so on. Others are able to let everything go limp at the same time — almost like letting air out of a balloon. Either way, you should soon feel very relaxed, and your deeper, slower breathing pattern will help you to stay relaxed.

If you find yourself thinking about preparing dinner or some other responsibility, tell yourself that in 45 minutes you will have time to deal with it. Right now, you are simply going to relax and empty your mind of everything. After 15 or 20 minutes, get up from the chair, pick up your camera and start making photographs of the object you selected earlier. While you are photographing, don't force yourself to make a lot of pictures. Stay relaxed, spend all the time you want observing your subject matter, and make only two or three pictures, if that is all you feel like. Above all, don't start worrying about whether or not your pictures are good ones. Simply enjoy yourself. After 45 minutes, put your equipment away and resume your daily routine. You may want to repeat the first week's exercise for another week, or longer, before moving on to the next exercise.

Second week: As often as you can, but at least once every other day, sit down in front of something that you find visually attractive — a clump of flowers, a heap of empty paint cans, a basket of yarn. You can use the same object every day or choose a different one — it doesn't matter, as

long as your interest is sustained.

First, close your eyes and start to relax. By now, you should find this easy to do. As soon as you feel completely relaxed, open your eyes and look at the object in front of you for a moment or two. Next, slowly let your subject matter go out of focus. Relax your eyes for a minute. Refocus and select some part of the object for careful observation. Study it briefly, then relax your eyes again. While your eyes are resting, make yourself aware of the colours in the out-of-focus shape.

Each time you refocus your eyes, pick a different part of your subject matter to observe carefully. If you are looking at a small houseplant (perhaps a geranium with a few leaves and a couple of blossoms), examine in turn the veins of a leaf, the arrangement of petals on a blossom, the hairs on a stalk. As you relax your eyes after each short period of observation, watch the leaves, petals, or stalk as they go out of focus.

You will find this exercise continually interesting as long as you keep looking for new details. See how many details you can find. For example, look at leaves, then look between leaves. What shapes are formed by the empty spaces? What colours are there? Caress the surface of a leaf — with your eyes. What does it "feel" like? Soft, rough, hairy, cool, bumpy?

Next, imagine that you are small enough to drive a tiny car over the leaf's surface. What would the ride be like? What obstacles would you encounter? Where could you park most easily? All of these questions will make you observe the leaf's surface with new awareness of physical details.

This exercise may become so interesting that you spend all of your time examining the plant, and never make any pictures of it. If this happens don't worry, as nothing could be more helpful in improving your photography than developing an acute awareness of your subject matter. This should be an exciting week, even if you don't have a single photograph to show for it.

Third week: Repeat the exercise of the second week, and add two easy steps. First, when you look at a leaf or blossom, try to see it only as a

shape, with no surface details. Visualize only the contour, ignoring texture and depth. This will be easiest to do with back-lighted parts of the plant, so start with them. Then, try it with front-lighted and sidelighted parts too. Turn the plant, and see how the shapes change.

Second, ask yourself what part of the plant you like most of all. Is it a blossom, a curled leaf, the way a branch flares away from the main stalk, or the downiness of the leaves? What do you like least? Is there anything you strongly dislike? Perhaps a lurid discolouration in one leaf? What part of the geranium do you feel sorry for? A broken leaf stalk? A small bud attempting to open its petals under a huge, fat blossom? In short, respond to the plant with your emotions — as freely and as fully as you can.

Later on, when you are cooking dinner, you can ask yourself why you feel sorry for the broken stalk and the small bud. This subsequent analysis is very important too, because it will help you to understand your reactions to any subject matter, and why you photograph it in particular ways. Your feeling for the broken stalk is probably a learned response - you feel sorry for anything that has been injured. But why do you feel sorry for the small blossom rather than the large one above it? Do you feel that the large flower is preventing the small bud from opening? Try to generalize. Do you dislike dominant objects and persons? Do you regard them as bullies? Do you avoid strong, bright colours in your pictures, because you feel in a sense sympathetic toward less saturated hues and muted tones? Why don't you feel sorry for the big blossom which is about to be pushed out of the way? Don't feel silly in asking questions like these - of yourself and of other photographers. They are important steps in improving the quality of your visual thinking and your photographs. You will see better when you understand why you are emotionally attracted to some objects, colours, and shapes, and repelled by others.

Once you have tried these exercises, you will notice a definite – possibly a dramatic – improvement in your powers of observation. You will also discover powers of imagination you didn't know you had. Riding to work on the bus will cease to be an ordeal, and will become an opportunity for visual exploration. You'll start to study reflections in

metal bars, shadows in people's clothing, the nuances of colour and texture in people's hands. Sitting at your kitchen table with a cup of tea, you will become fascinated with distorted window reflections on your refrigerator door (a favourite pastime of mine), and even more, you will come to realize how much you value these times. They will become very special to you. You will have more ideas for photographs than you ever dreamed possible, and be itching to reveal your new awareness of the world around you. These are the rewards of relaxed attentiveness.

Deliberate experimentation is a good way to start thinking and seeing in new ways. If you examine the results carefully, you will be able to apply what you've learned to a variety of situations. Many times over the past several years I have made photographs while zooming in or out with my zoom lens. One day I realized that all of my zoomed photographs contained bright, active hues. I had never tried the technique with subject matter containing little or no colour. So, to try something new, on the next cloudy day I started photographing bare trees against a grey sky. After several tries I started getting the results I wanted.

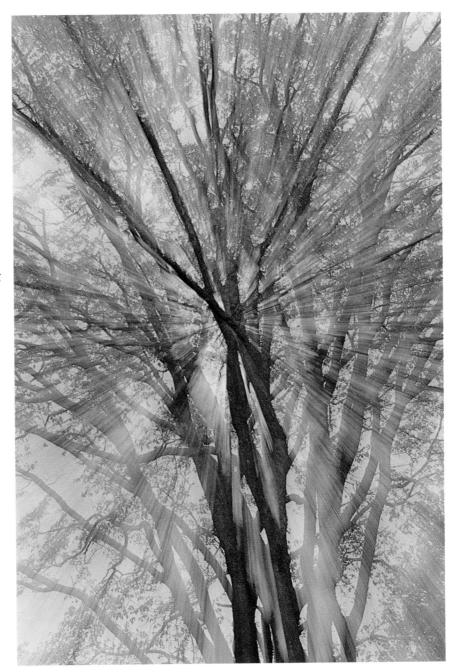

I have often photographed back-lighted leaves rimmed with frost, but I always concentrated on the leaves and ignored the line and direction of the stem. This time, I cropped both leaves. It reduced the impact of their shapes enough to emphasize the expressive quality of the lines of the stem and twigs, but not enough to destroy the informal balance of shapes. If you find yourself repeating an approach again and again, it's probably time to branch out and try some new ones.

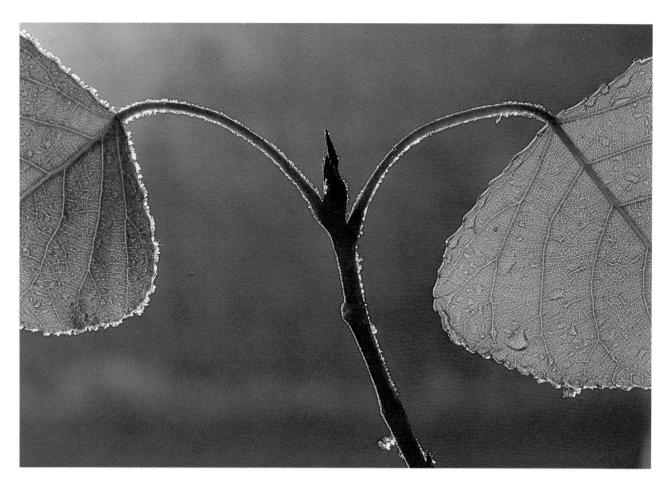

November is my favourite month for photography. Scenes tend to be monochromatic, which accentuates the expressive power of tones. Even the most familiar things offer new picture possibilities. The puddles near my front door suddenly display exciting designs — the curved lines of light tone create vibrancy and movement. I don't use special equipment to make pictures like this, just a standard lens and careful observation.

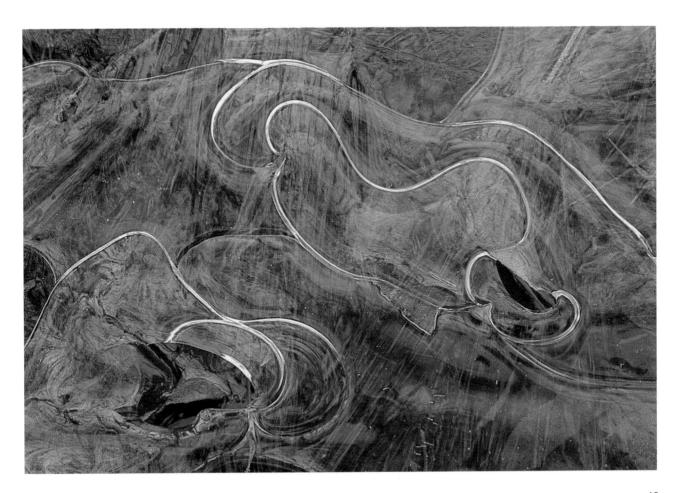

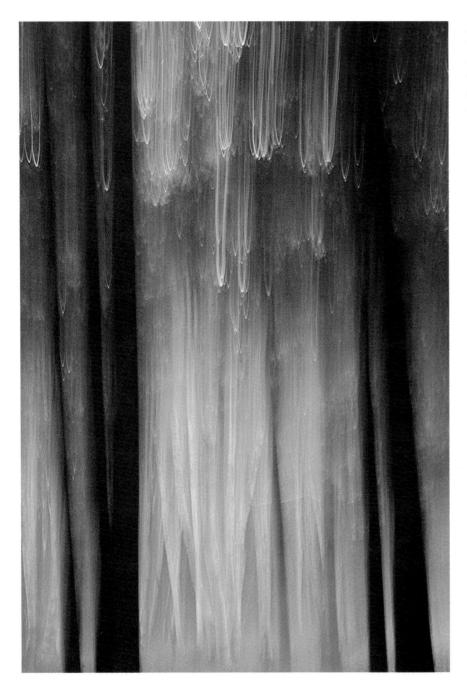

A tradition-breaking exercise in thinking sideways led to this image. To begin, I carefully composed a picture of trees and set my lens at f/22 so I could use a very slow shutter speed. Then, I tilted the camera up and down rapidly as I pressed the shutter release. I did this for six exposures, then made other compositions and repeated the exercise several more times until I had finished the film. About ten pictures were successful, especially those of trees, because the camera movement accentuated their natural vertical structure. Technique should be harmonious with subject matter.

Many subjects require surrounding space, rather than close-up treatment. Frequently, living creatures are photographed best when the photographer allows room for them to move. These flamingos are small in the overall picture area, because they need space through which to soar. They remind me of jet airplanes flying in formation. While the birds are located near the central vertical axis of the photograph, the possible static effect of this position is offset by two other elements – the implied line of movement or invisible jet trail behind the flamingos, and the horizontal line of birds in the lower right corner. These visible and invisible lines have pictorial weight that balance each other.

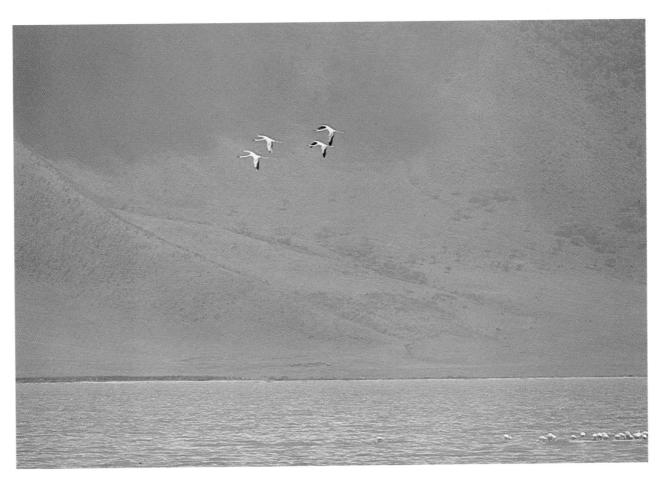

Sometimes a camera can see what the human eye cannot; you can learn how the camera sees only by making pictures and examining them. For example, this is a 30-second time exposure made before sunrise when some purplish-pink clouds were reflected in the rippled surface of a creek. The scene did not actually look like this, because the ripples were constantly changing; but from the experience of similar situations, I knew a long exposure would make the surface calmer and the colours more intense than they were. Experiment with various techniques, so you'll learn to expect what the camera sees.

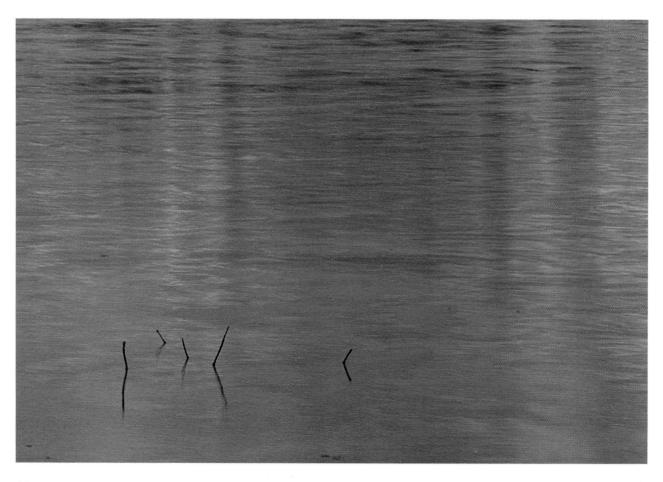

Use your equipment to capture the feeling or mood that subject matter evokes, rather than making only literal documents. In this photograph, I wanted to emphasize the delicate beauty of a tiny bloom, strengthened by nature's softest lighting. So, I used a 100mm macro lens at minimum focusing distance (about 20cm) and maximum aperture (f/2.8) to enlarge the setting sun. The major problem was excessive contrast between foreground and background; so I chose a camera position that filled the foreground with a profusion of tiny, light-blue flowers, and then waited until the sun was at the horizon – its point of least brilliance – so the contrast would be reduced.

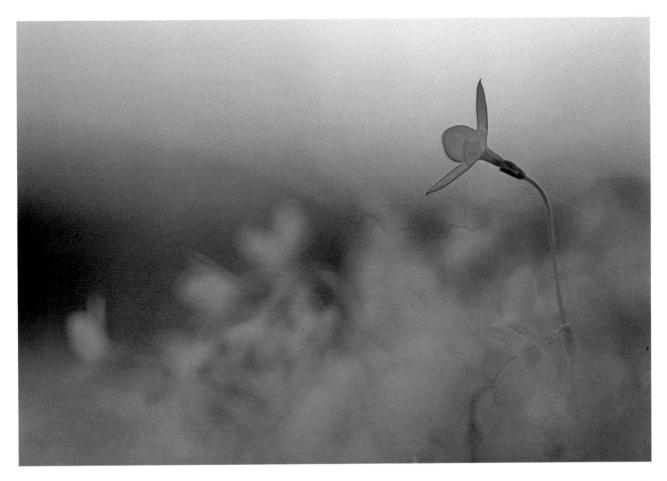

Your imagination plays an important part in visual expression. A good exercise for developing your imagination is to attempt to define a scene in a new way, trying to find a likeness between it and something animate, for example. In this photograph, the sand dune lying between sky and water reminds me of a huge bird with its wings outstretched in flight. A sense of freedom seems inherent in both the dune and the "bird" — because of long, uninterrupted lines, light tones, and blue spaces above and below. When you find such similarities in your surroundings, you can use photographic techniques and composition to make sure they will stand out clearly.

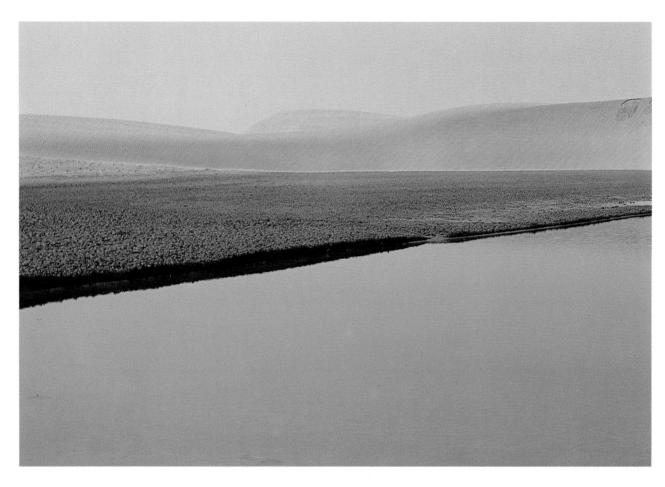

Is this a scene from the world of Jules Verne? A dreamscape? Before you try to pin it down, indulge in fantasy. Imagine! Feel! Give your sense of wonder full freedom. In making this photograph, I couldn't simply point my camera and shoot; I had to consider how the slightest change in position would alter the colour balance and mood. So after careful examination, I directed the lens slightly to the right, allowing the blue to dominate, but letting traces of orange scatter throughout the frost pattern on the window pane. Because the lens was not at right angles to the window and because I wanted the entire pattern in focus, I used the smallest lens opening for maximum depth of field.

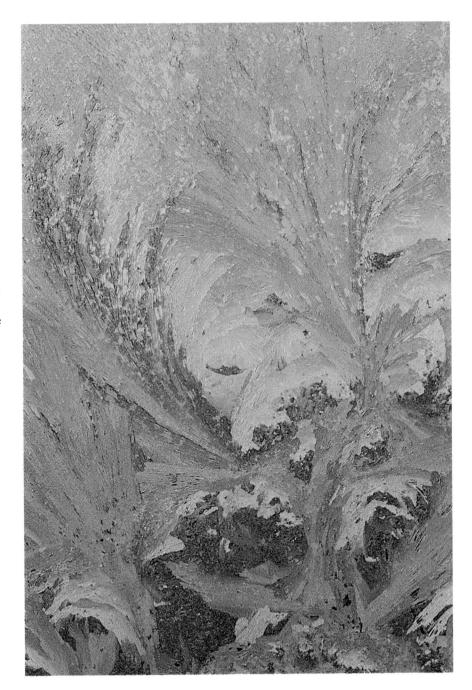

What do rocks suggest? Weight? Strength? These characteristics are the subject of this photograph. Therefore, the subject matter must be organized in a way that expresses it clearly. By carefully choosing a camera position to make maximum use of the shapes created by the contrast of tones, I was able to make the lower tip of the middle rock the most significant point in the composition. This point is hardly rivetting enough to be called a centre of interest, yet it receives the full weight and powerful downward pressure of all the lines and shapes above it, and expresses the strength and heaviness of the rocks.

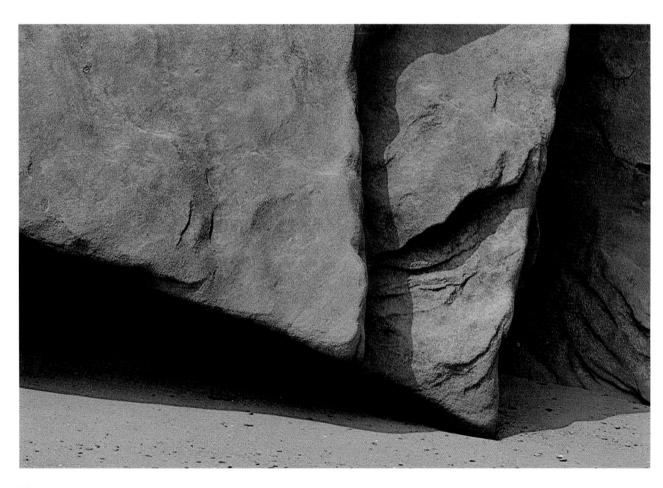

Good observing is more than just noticing objects. It means recognizing the contrast, lines, shapes, and textures that make up objects and their surrounding spaces. Back lighting often creates the strong contrasts that delineate lines and shapes – here the lines of the grass and the lower border form a triangle. The simplicity of the composition allows the tension between the tones and hues, and the thrust of the lines to add a strong sense of the dynamic.

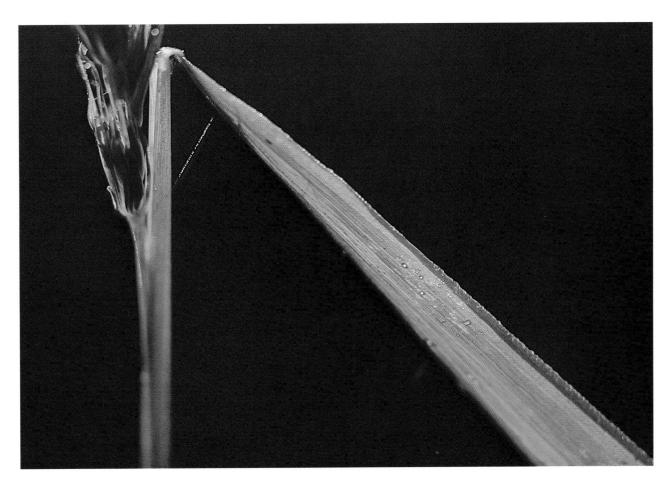

Abstracting and selecting are important to making good photographs. First, you abstract the essential visual elements. In this case, I felt that shape was the most important element. As the scene really contained only one "colour," blue, I thought in terms of tone: the snow was white in tone, the gravel dark, and the sky about middle grey. The differences between these tones created shapes. Then, I had to select the proportions of these shapes in relation to each other and to the entire picture space. Finally, I positioned them within the frame.

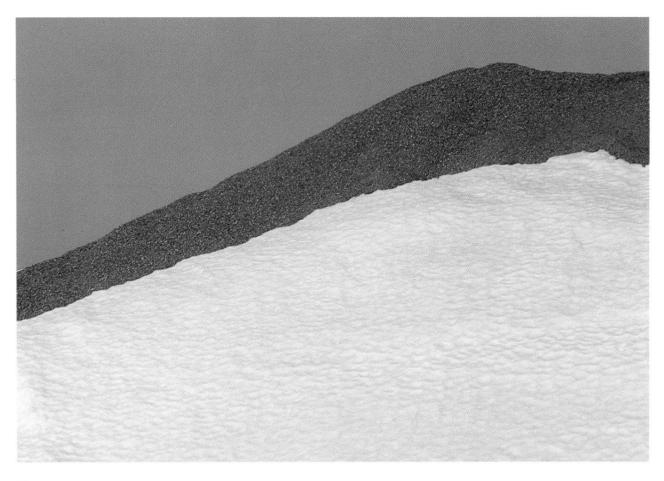

Learning to imagine

Imagining

By producing abstract thoughts and picture images in the "mind's eye," your imagination organizes your sensory experiences so you can understand them. Imagining is mental image-making. Everybody has imagination and uses it constantly, but there are ways to develop this power further.

THE MIND'S EYE

The images seen in the mind's eye are based on pictures and patterns from previous experience, and so depend to a great extent on your memory. The more sensory experiences you have, the more material your imagination has to work with. The photographer who observes his environment carefully, who lets his eyes linger on physical details, is feeding his imagination. Teachers sometimes speak of children who have been "deprived of sensory experiences"; these children have difficulty forming ideas and working with concepts until their sensory experience has been enriched.

Your mind's eye sees in many ways. Dreaming is one way. Reverie – when you are wide awake in a particular place but your mind is elsewhere – is another. You are "off in the clouds," or "wrapped in thought" – you are imagining.

Abstract thinking is another form of imagining, a conscious form which you use regularly, usually without trying. Your ability to think abstractly begins to develop shortly after you are born. At birth you are vaguely aware of two things - yourself and sensations. Almost immediately the sensations you experience begin to form patterns - the large, light, round, smooth, vellow object that moves when you touch it becomes a plastic ball. Before very long, you learn a name for it, but even before you do, you recognize another smaller, heavier, round, smooth, red object as also being a ball. You recognize it as being a ball because of your sensory contact with the first ball, and because you are beginning to develop recall. Your perception of similarities shows that you have developed a rudimentary ability to generalize, or conceptualize. For a long while, all the concepts you develop are based on percepts, that is, on physical objects that you have experienced with your senses. While you are eventually able to understand concepts that have no sensory beginnings, in other words, to engage in purely abstract thought, you will make constant use of perceptual concepts as long as you live. Through this process of mental development, you move from uncertainty to order. This is a creative activity in which everyone of normal mentality engages. It is the same process you go through when you are working to improve your photography, or striving for more effective expression.

Sometimes, imagining gets in the way of further imagining, or one kind of imagining gets in the way of another kind. Remember labelling — one of the main barriers to observing and imagining. Labels are concepts or generalizations, and they can tend to short-circuit our perception. We look at a cup and what we see is "cup-ness," not the flaring rim, the curving handle, the mottled design, or the reflections of the windows on the side of the cup. In short, labels can limit the amount of material accessible to our imagination.

On several occasions I have asked a new class of students to draw a house. On average, seventeen of twenty students will draw essentially the same house – a basic form showing the front, one side, and the roof – despite the fact that probably none of them lives in a house like that. What they are drawing is the label, the common concept of a house which they learned in school or elsewhere. A couple of students may vary the pattern a little, and one may draw the house in which he or she lives, indicating that the student has observed the details carefully

enough to reproduce them with considerable accuracy. So far, nobody has drawn a dream house – one which he or she would like to build and live in.

We have been conditioned to put a low priority on sensory experience, while putting a high priority on developing logical thought processes through the "three Rs." This means that only part of our imagination is developed, and the part that suffers is the part we most need for expressing ourselves visually. Thinking depends just as much on picture images as it does on word images, and should be used equally in education.

The creative process of making photographs often involves three steps. *First*, you conceive or imagine a theme. *Second*, you find (that is, perceive) subject matter that expresses the theme or concept. *Third*, you conceive the best way to organize the subject matter and to use your photographic tools. For example, you may conceive of a photographic essay on family life, then perceive (for days, weeks, or months) the people and events you want to photograph in order to explore your theme, and conceive (on each occasion you make photographs) the best way to compose the pictures.

In order to stimulate the creative process of making photographs we must 1/ free ourselves of long-established habits of thinking based primarily on our academic training, which tends to emphasize logic and rigid patterns of mental development, and 2/ enrich our visual lives in order to develop imagination. Here are several suggestions to help you.

EXERCISING YOUR IMAGINATION

1/ Begin with some of the visual exercises in thinking sideways suggested on page 29. Try breaking the rules and escaping the labels. Thinking sideways will stimulate your imagination.

2/ Make frequent use of galleries and libraries. Study pictures in other media – paintings, drawings, batiks, weavings, and so on. Think about how they stimulate your imagination. Resist the urge to ask "What is it?" when you are confronted with a picture that you don't understand. Don't ask for a verbal explanation of a visual puzzle. Resist the label! If

you don't recognize the subject matter, make of it whatever you want. Use your imagination. Let your eyes roam over the shapes, colours, lines, and textures. Ask yourself what you like about the picture. Does it make you feel happy? Be willing to respond emotionally.

Similarly, when a photograph intrigues you or appeals to you strongly, concentrate on its expressive qualities. Enjoy it! Resist the temptation to inquire immediately about the tools and techniques that were used. Concentrate on using your eyes and on stretching your imagination.

3/ Look for visual similarities between subjects and subject matter. Select a *subject* such as "tranquility." Then ask, "What *subject matter* expresses my subject — and why?" Then you'll be on your way to finding the right visual features to emphasize in order to make a photograph that expresses tranquility. (It is important to remember the difference between the subject and the subject matter of a photograph. The subject is the theme or topic, such as "the family." The subject matter is what you point the camera at, such as family members in various poses.)

Play charades with a group of photographers. This is a game that requires you to communicate by acting out pictures. Use only subjects such as "delicacy," "dullness," "grandeur." Whoever is "it" acts out a subject using his body to describe the shapes, lines, sizes, and positions which express the subject. Arms opening as they sweep upward may be a clue to recognizing "grandeur," for example. Charades develops visual imagination. It's fun, and helps people to be less inhibited by what other people may think.

4/ Practise foresight. Before you actually photograph a football game, for example, make the photographs in your mind. Imagine yourself at the game – zooming in on a huddle, then panning a player who is racing with the ball. Dodge out from behind somebody who jumps up in front of you. Miss an exciting shot and wait for the situation to repeat itself. Practise this exercise in imagining five, six, or even ten times. On the day of the actual game you will discover not only that you have confidence and visual acuity, but also that you have worked out in advance solutions for many of the problems you may encounter.

5/ Dreaming is recognized as one of the most important forms of imagining. Many new ideas come to us through dreams, because the normal restraints of everyday life, which tend to inhibit imagination, are absent. Visual problems may be solved while dreaming. For instance, after thinking about the football game you were going to photograph in the preceding exercise, you may find that, as a result of dreaming, you visualize yourself in a camera position that could produce a truly exciting shot — one that never occurred to you while you were awake. 6/ Indulging in fantasy helps us to discover new ideas. Try looking at things in crazy ways. For example, "What if a dog had wheels instead legs?" Then try to make pictures of your fantasy. A student of mine made a photograph of my German shepherd by panning while the dog was running over very rough ground. The panning of the camera, along with both the forward and up-and-down movements of the dog's legs, made her hind legs look like wheels in rapid motion.

What kind of equipment and techniques would you need to photograph the following ideas? "What if garbage dumps were beautiful?" "What if I could never hold my camera steady?" "What if flowers visited butterflies?" "What if frying pans had soft handles?" The "what if" habit is an important technique, frequently employed as standard practice in scientific circles to find new ideas and approaches to problems. Don't be afraid to engage in fantasy.

Try to exercise your imagination in all aspects of your life. Make it a habit. The more widely you practise imagining, the more likely it will be to influence your photography. Good imagining can be infectious; catch it and pass it on to other photographers.

Abstracting and selecting

The expressive quality of a photograph depends on the photographer's ability to abstract, that is, to separate the parts from the whole. Abstracting is recognizing both the basic form of something and the elements that make up that form. It is an important skill in making good photographs, because it helps you to spot the visual elements (shape, texture, line, perspective, and colour) that are common to all subject matter, and to understand the role they play in composition.

Abstracting is not something you have to learn; you do it all the time without being aware of it. But perhaps you don't do it nearly as well as you might. Improving your ability to abstract takes practice — both when you are using a camera and when you are not. You can practise anywhere, anytime.

Once you have abstracted the visual elements most essential to a scene or an event, you have to select. Selecting is choosing those parts of the subject matter that will best express the character of the scene or the meaning of the event.

Think of making a stew. Abstracting is recognizing the basic ingredients or elements — meat, vegetables, herbs, and liquid. Then you have to select the particular meat (beef), vegetables (potatoes, onions, carrots, celery), herbs (bay leaves, oregano), and liquid (red wine) that are necessary for the kind of stew you want. Photography, like cooking, is very much a matter of identifying the basic elements and knowing how to put them together in various expressive combinations. If you don't know the basic ingredients for stew, you will likely end up with a

strange supper. Similarly, if your ability to abstract visually is underdeveloped, you will probably end up selecting subject matter that expresses your idea poorly.

Whereas thinking sideways involves chance and encourages completely new ways of looking at things, abstracting brings order and structure to your seeing and your photography. Abstracting and selecting help to make clear expression possible.

Visual design does not exist for its own sake, but for a purpose. In nature, that purpose has to do with survival. The large fierce "eyes" on the wings of certain moths are there to frighten away predators. The colouration of flowers attracts insects, which will pollinate the flowers, and thus ensure reproduction of the species. In art, the purpose of visual design is to express clearly the subject or theme and the artist's response to it.

The comparison between art and nature is not an idle one. Nature observes the rule of simplicity, which means that nothing in nature is more complex than it has to be in order to fulfil its particular function. Since human beings are part of nature, they are also controlled by the rule of simplicity. Our eyes see things in their simplest possible form; they perceive natural order and tend to reject unnatural arrangement, or to correct it subconsciously.

One morning when you are sitting in the kitchen sipping your last cup of coffee before work, consider the essence of a kitchen. A kitchen is a place for storing and preparing food. As you sit there, start to remove mentally everything that you can — without destroying the image of the room as a kitchen. You will end up with the essentials, such as the cupboard, the stove, the refrigerator, a cooking pot, a cup and plate, and some eating utensils. It's not much, but with these items it could still function as a kitchen. This exercise will help you get to the essence of any subject matter. Often, the fewer objects you use to express a concept the more likely your viewers are to grasp it.

There is a simple exercise in abstracting which can be practised anywhere. It will help to sensitize you to the importance of tones in composing and exposing any kind of film. Choose a part of the scene in front of you — one wall of a room, a corner of the backyard, a small

section of the street. Examine this area carefully for differences in brightness. First, locate the parts that look white; next, find those that appear to be black; then, identify those that seem to be middle grey. Soon you'll find that you are responding to the view in terms of brightness, rather than colour, although you may find that some colours are difficult to define in terms of brightness.

Repeat the exercise ten minutes later in a new situation. Stop as soon as you become a little tired or bored, then try it again in another ten or fifteen minutes. You'll soon find that you are filling empty seconds by looking for degrees of brightness, switching the exercise on for a moment and then off again. Habitual practice will result in development of a skill that is important for both accurate exposure and good composition.

However, it is one thing to recognize the differences between tones or to spot tonal gradations, and quite another to use these tones to convey a message or feeling. So, choose subjects or themes such as "freedom," "gloom," and "peace," and decide which tones or combinations of tones seem to express these ideas. Which tones in the scene make it gloomy or peaceful? How much of a particular tone is necessary in order to convey this effect? How much of another tone is necessary in order to change it?

Here is another easy exercise. First, ask how the room you are in makes you feel (comfortable? depressed?). Second, abstract the elements that make you feel that way. If the room makes you uncomfortable, for example, then start to ask why. Perhaps you will discover that it seems to be a clutter of shapes — too many rectangles, triangles, and circular objects of competing size and brightness. You have abstracted confusion as the cause of your discomfort. Then, start imagining physical changes that will make the room comfortable. Decide on the basic shape for the furnishings you will use. For example, if you select a rectilinear pattern for the room, perhaps you will remove the triangular coffee tables, and replace them with oval or rectangular ones with rounded corners. Perhaps you will get rid of the pictures with the rigid circular frames and hang batiks, which are more compatible with the pattern of the room. You are rearranging to achieve comfort. This is designing with a purpose.

A similar way to learn good design is to choose four or five expressive

subjects or themes, such as "stiffness," "hilarity," or "threat." Then have somebody place several small objects on a table, quickly and without any special thought, so you will be faced with a variety of things — such as bottles, vegetables, a comb, soap, gloves, a book — to work with. Now you are ready to begin. First, abstract. Ask yourself which expressive elements — such as shapes, colours, textures — convey the theme of stiffness. Second, select. Choose those objects that contain vertical lines or rigid shapes. Then, arrange the objects: arranging to express the theme is also part of selection. If you feel that your arrangement expresses the theme well, photograph it, using your photographic tools and techniques to strengthen the expression even more. Then, put all the objects back on the table and move to the next theme.

Abstracting and selecting are important to all types of photography. Successful photo-journalism, social documentary, and candid photographs of people all provide information, but information is only a listing of facts unless it carries expressive force. Many documentary photographs carry very strong messages or record vividly the emotional impact of an event. They are expressive. If you are interested in producing a photo-essay on industrial pollution, you will have to identify the visual factors that express pollution (dark tones, distorted shapes, etc.) and choose the objects, activities, and times that reveal them, while reducing or eliminating the visual impact of those that do not.

When a child thinks of drawing his mother, he may intuitively abstract love as one of her most distinguishing traits, and in his drawing he leaves out many of the physical details of her body, but not the one that counts — her smile. The child abstracts and then selects — quite naturally. The result is an honest and clear expression of the mother's attitude and the child's response. Photographers can learn a good deal from children's art.

Learning to express

The challenge of expression

Whether you are a mother or father who enjoys taking snapshots of your children, a tourist visiting Africa for the first time, a naturalist making pictures of wild plants, or a photographer on the staff of a large daily newspaper, the goal of your photography is effective expression.

When we look at a lake, we are first aware of what the lake expresses. We see its tranquility or turbulence, not its shape or colour. When we look at a face, the first thing we notice is what the face reveals — hostility, joy, sadness. The message is expressed by the sum of all the facial features; our observation of each detail of the face comes later.

There is a good reason for our noticing expression before physical detail. Our senses have a very special purpose — to interpret what the active forces in our environment (people, animals, weather, traffic) are doing, so we can respond appropriately. Our survival depends on it. The first question our senses ask when we perceive anything is whether or not the object is friendly. Friendliness and hostility are the basic expressive characteristics of all forces in our environment. We "see" them first.

Our senses tell us that a tranquil lake, a bear retreating, a parked car, and a choir singing are not threats, so we take no action to defend ourselves. Our senses also tell us that a turbulent lake, a bear rushing toward us, a car hurtling out of control, and a group of people shouting and waving sticks are probably hostile to our well-being. When we view photographs, we respond emotionally — almost as if we were confronted with the actual subject matter.

Once we have determined what the subject matter expresses (that is,

its subject or theme), we may notice *how* that expression was achieved – by means of particular shapes, tones, or colours. Many people simply stop observing subject matter after the initial glimpse, and can give only a sketchy description of it later. I'm like that with cars. Once I know that they aren't going to run me down, I ignore them. As a result, I fail to see the details of their construction. However, a photographer of cars, in order to make good pictures of what his subject matter expresses, will be far more observant. He will ask *how* the subject matter is expressive.

EXPRESSION

When you make pictures, take advantage of the natural sequence in which your senses provide information. First, ask "What does the subject matter express?" (Possible answer: joy.) Then, ask "How does the subject matter express it?" (Possible answer: the joy is expressed through soaring vertical and oblique lines, light tones, and bright colours.) Answering these two questions, in this order, is the first step in deciding how to compose a photograph. The purpose of good composition or visual design is to let the subject matter express the subject in your photograph.

Sometimes expression means "self expression" – you simply want to photograph how you feel. Self expression is revealed partly by your choice of subject matter, which means not merely the objects you select, but also their colours, shapes, and lines. These may be more important to you emotionally than the objects themselves. For example, you may express sadness or depression by using black tones, or happiness and exuberance with light tones, vibrant colours, and dynamic, oblique lines. But whatever your subject, as a photographer you must let already-existing things speak for you.

Remember that by changing lenses, filters and techniques, you are altering the way your subject matter appears. When you switch tools or techniques, you must still respect the subject matter, or it may not be able to speak for you.

What should happen when you make a photograph is what happens in nature: the subject matter expresses the subject or theme and the person who sees it responds. Your task as a photographer is to make sure that the subject you have chosen is expressed as clearly as possible in your pictures, so viewers will be able to respond appropriately. This is the fundamental principle of good design.

Thinking of subject matter as being expressive in its own right is more important in photography than in any other visual medium, because every time a photographer picks up a camera, he is confronting already-existing shapes, hues, and textures. When you document the expressive nature of your subject, you will also express something of yourself. Nobody else will photograph the subject in quite the same way you do.

On several occasions I've given each member of a group of students a hard-boiled egg and asked them to make at least twenty photographs of it during the following 24 hours. After they have completed the exercise, each person selects two or three photographs that most clearly express his or her response to the subject matter. The variety of photographs in the assembled show is always astounding, in spite of the fact that everyone began with a white egg. In one case, a student presented a study of white on white - an egg on a clean, white sheet of paper which expressed sheer simplicity of form. Another, by using double exposure, showed the egg drifting languidly across a blue sky among towering cumulous clouds. Still another placed the egg next to a nude torso and used side lighting to emphasize the similarity between shape and texture of the egg and the human body. A fourth student carted his egg off to the local cemetery and stood it on its end in the short grass; then, by moving very close with a wide angle lens and maximum depth of field, he composed a photograph in which the egg seemed to be emerging out of the ground and looming larger than any of the tombstones. In this way, he clearly suggested the progression of life, which the egg symbolized to him. A fifth student placed her egg on the ground just in front of the wheel of a truck, and conveyed a sense of the egg's fragility by implying its impending destruction.

This exercise revealed both the expressive power of simple subject matter – an egg – and the diverse ways in which people respond to it. Photographers who ask "What does this egg express?" and then attempt to photograph that, are just as likely to come up with a wide variety of

interpretations as photographers who ask "How can I express myself by photographing this egg?", and differences in approach and style will be just as clear. However, the photographers who respect their subject matter and value its expressive power will be far more likely to make photographs that communicate with others than those who are too introspective in their approach.

Try exercises in observing and photographing simple subject matter, such as a small wooden box, a ballpoint pen, or a potato. Make a minimum of twenty pictures. Ask four or five other photographers to do the same exercises, and then view and discuss the results. Encourage everybody to react. Such exercises may be even more valuable if you invite someone who draws, for example, to join the group and ask him or her to make 20 one- to three-minute sketches of the chosen subject matter. Discuss the sketches along with the photographs and see what you can learn from each other. How does each medium aid expression? How does each limit it?

EXPRESSION IN SUBJECT MATTER

We respond with different emotions to different shapes, textures, lines, and colours on the basis of qualities we perceive in them. This is what Rudolph Arnheim in *Art and Visual Perception* calls "expression embedded in structure." For example, a circle doesn't only look different from a triangle, it "feels" different. Red feels different from blue. People respond differently to various patterns of letters that do not form words; for example, EEOEEOEE makes us feel quite differently from ZUMZUMZUM or LARRONTOCK.

Through a picture of a drooping willow tree (subject matter), a photographer can convey sadness (subject or theme). However, it is not simply the photographer's technique, nor the viewer's interpretation of the tree, that creates sadness. There is something inherent in the tree or, more accurately, in the drooping lines, that is analogous with what we understand sadness to be. It might be called a hidden visual likeness. A dancer may convey sadness through slow movements, a certain sagging of her limbs, and a drooping head. Since she doesn't speak to us, we

depend entirely on her shape and movements (pictures) to recognize her meaning.

Let's think of other lines and the messages they convey. We speak of a vertical line as being stiff or formal, of an oblique line as being active or dynamic. Yet, in each case, we have the same straight line — it is merely positioned differently in relation to our eyes. When we speak of the line in these different ways, we are recognizing expressive qualities in the position of the line. Presumably, these qualities are there whether we recognize them or not, but we are likely to recognize them because our senses are designed to perceive and to respond to what exists.

Children's drawings make the point very well, and reveal something important about how photographers should work. Let's think again of a child drawing a picture of his mother. He pays almost no attention to producing a realistic likeness of her. Usually he makes a large head and virtually ignores her torso. He often attaches arms and legs, which may be only thin lines, directly to her head. Inside the circle which represents her head, he will place three dots or small circles for her eyes and nose, and inscribe a large upward-curving line for her mouth. The child doesn't concern himself with what is unimportant about his mother, but gets right to the point of telling us that she is loving, happy, and warm. The big smile is all that really matters.

A child seems to recognize intuitively that a short line curving upward at both ends expresses positive feelings. Perhaps it can be argued that he has learned the expressive relationship between lines and human moods by observation, but what cannot be disputed is his understanding that such a relationship exists, and that it is important. Still more, he knows intuitively that simplicity gets a point across clearly, which is why he ignores his mother's torso and draws only rudimentary limbs. They have nothing to do with what his mother means to him.

Recently my eight-year-old niece and I spent a morning making oatmeal cookies. We had loads of fun. Afterward, she presented me with a drawing which consisted of a tree, a haystack, a rainbow, and several cookies. In this idyllic picnic scene, the cookies were huge — as big as the haystack and not much smaller than the tree. Also, the cookies were every colour of the rainbow; the meadow (which she did not bother to

draw, since I was obviously to assume it was there) was strewn with them – gigantic red, yellow, green, and blue cookies. Her drawing told me very clearly how much she had enjoyed making the cookies with me.

My niece relied on size and colour to express happiness and appreciation. Nobody had to tell her that if she made the cookies large and colourful, I would understand how she felt. She relied intuitively on the expression that springs from large, brightly-coloured circles — that is "embedded in their structure." If she had struggled to produce a realistic scene, she would have forfeited expression in the final result. Those elements that conveyed the meaning of the event would have been played down for purely mathematical or technical reasons.

If you look at children's art, you will soon see that most children are relatively unconcerned about the exact reproduction of geometrical shapes and patterns. However, they are very concerned with representational concepts. Like artists in any medium, they portray the sense of things, the general or universal concept from which the particular derives its meaning.

Good art teachers, which includes good photography instructors, are likely to suggest exercises that will encourage their students to deal directly with expression, knowing that the students will automatically consider the principles of visual design and learn them as useful tools. Exercises in pure design (which don't have an expressive purpose) are seldom useful except as skill training, because they deprive the working experience of any meaning. It's much more instructive to try to photograph "happiness," for instance, which may involve learning about the expressive qualities of curved lines, light tones, and bright hues, than merely to photograph curved lines or light tones with no expressive purpose in mind.

A person who photographs a bear close up and facing the camera knows the bear can express "threat," but if the photographer waits until the bear ambles across a meadow and heads toward a clump of orange maples, he will emphasize the naturalness of the bear in its surroundings and evoke pleasant feelings. By waiting for the bear to move, thus altering its distance from the camera and its apparent size, the photographer takes advantage of a change in expressive elements. He

knows that a potentially hostile force *appears* less threatening at a distance, because it *is* less threatening.

The greater the distance, the more time is required for an attack. Since objects that we generally know to be of a certain size, such as an adult bear, both are and appear to be less threatening at a distance, there is nothing artificial about a photographer making use of the emotional qualities expressed through variations in size and distance. If several people were to photograph the bear, the personal expression of each photographer would probably be revealed most of all by timing and the position of the bear. Each photographer would choose a slightly different moment, thus showing what he feels about the scene.

SUBJECT MATTER AND YOU

Thinking about what the subject matter expresses, rather than thinking about what you can express, puts several things in perspective. 1/ It puts the emphasis on seeing things outside of yourself. It helps you to let go of self and be much more observant of your environment. Careful observation is a prerequisite of good photography. 2/ Paying attention to the details of your surroundings will enrich your sensory experience and stimulate your imagination. 3/ First you see what the subject matter expresses, and then you respond to it. This is the sequence by which our senses provide information. 4/ This sequence of seeing, then responding, should be followed when making pictures. First, ask what is expressed; then, ask how. The answers will provide clear guidance about how to use the elements of visual design and your photographic tools.

This approach makes possible not only the greatest visual rewards, but also the greatest emotional ones. When you try to photograph something well, you are acknowledging both the value of what it expresses and your confidence in your response to it.

When I saw this scene, I immediately thought of the Creation. The power of the light streaming from the sky divided the blackness into water and land, day and night, and suggested emergence. Underexposure was the key to conveying the feeling that the scene evoked. I underexposed about two f/ stops from a normal daylight exposure in order to keep the dark areas dark and not overexpose the brilliant tones in the water. The underexposure also slightly enriched the warm hue of the bright areas. This warmth counteracted any sense of foreboding, without reducing my feeling of awe.

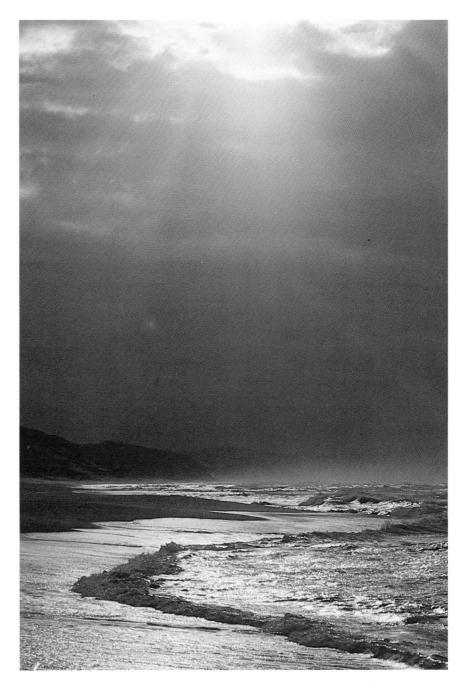

Since light conditions affect mood, a photographer may have to rush — or wait for hours to capture the right moment. The mood may also be altered by the choice of film, since every film reproduces tones and hues differently. For this scene I needed a film that would give excellent shadow detail without subduing the warmth of the golden light streaming across the distant hill. It is important to test at least two brands of colour films with your own equipment in order to increase your control over colours.

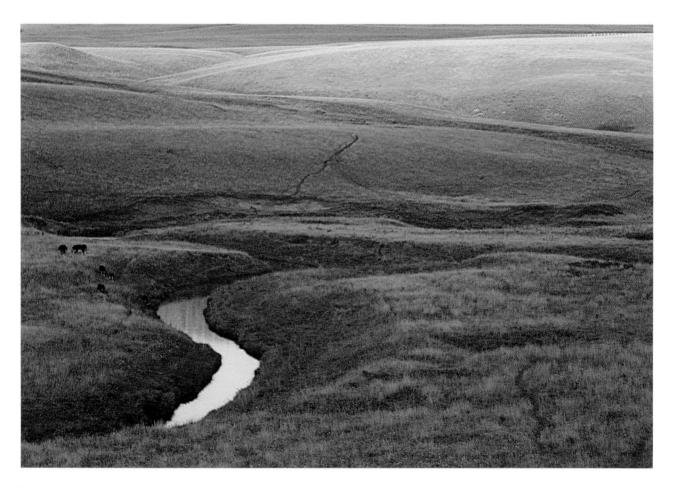

Two things affected me strongly here – the range of tones, and the dominating gentle brown hue. The tones created lines – in the hill and in the shaft of sunlight. Their arrangement in the picture space and the placement of the tree, which ties them all together, had to be considered carefully, but quickly – before the light moved. My response to the expressive power of the light brown hue may be stronger than your response to it. Colours evoke different emotions in different people, and have a major effect on what we photograph and on how we respond to the resulting images.

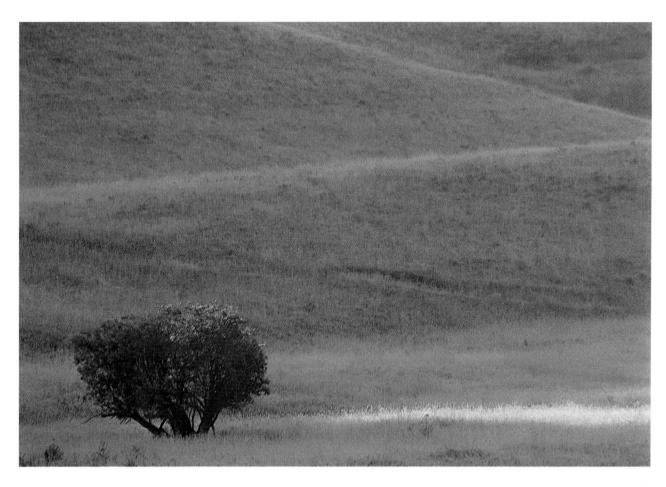

Because the woman was utterly absorbed in her weaving and oblivious to anything else, I chose a point of view that put the emphasis on her work, rather than on her. For this reason, the photograph reveals more about the weaver than if it had shown the woman clearly. Note that the lines of yarn converge slightly toward the bottom of the picture. This limited deformation (or distortion) creates oblique lines, which produce visual movement, and prevents the picture from being static, as it would have been had all the lines been perfectly vertical.

The subject matter of this photograph is totally different from the one opposite, yet in both cases the dominance of the vertical lines establishes a strong pattern. Abstracting or recognizing lines as the major expressive element was easy, but selecting which lines to include in the photographs and how to include them was more difficult. In this photograph, I decided to use a telephoto lens and a high camera position in order to emphasize the strong flow of curving vertical lines. By interrupting this pattern, the two horizontal lines add contrast and overcome visual monotony.

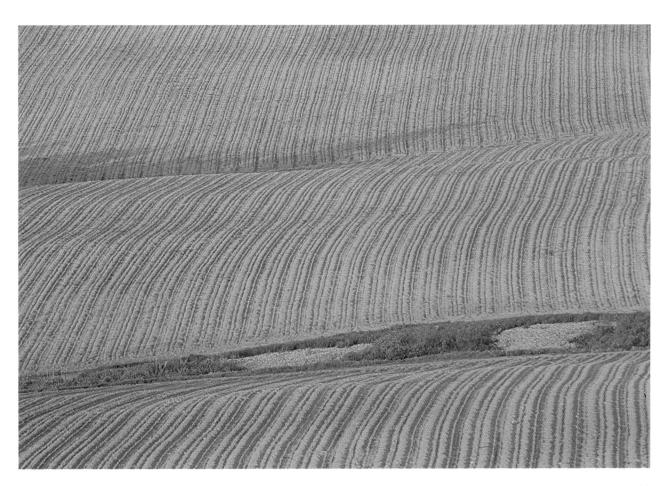

Dreaming is one form of imagining. Much of what we dream is related to our waking hours. In fact, all fantasies are based on reality. Exercises in fantasy help to develop the imagination, so that we begin to see things in new ways. For example, try to convey the feeling of a dream in a photograph. This image has only a slight resemblance to the original scene. By eliminating the foreground, and by cutting off the trunks of the trees so they became dark shapes soaring upward into a dream-world of mist and light, my feeling about the "mystery" of dawn was expressed more clearly.

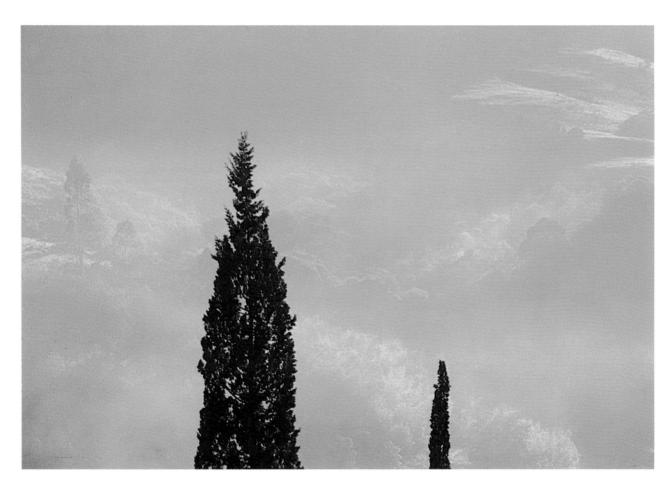

The warm colour of the late afternoon side lighting is the most expressive element in this scene, and influences my emotional response more than anything else. However, colour alone is not enough. The picture also requires form, which the lighting provides by means of the long parallel shadows. The patch of dark green in the background adds contrast and repeats the direction of the lines. I was able to make an exposure long enough to let the breeze blur the oats in the foreground slightly, producing a softness which is harmonious with the colour.

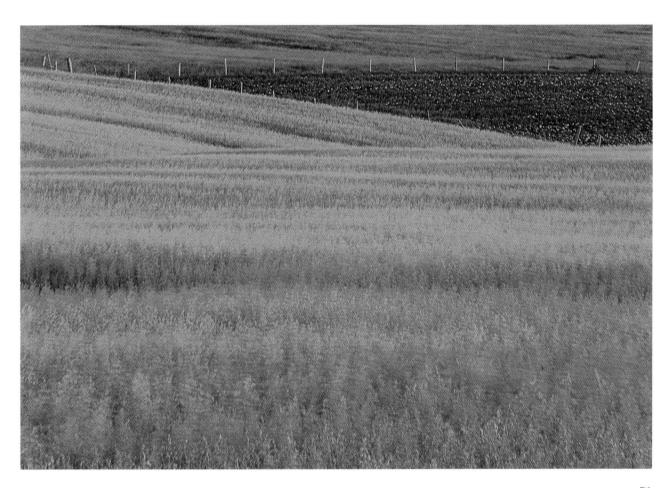

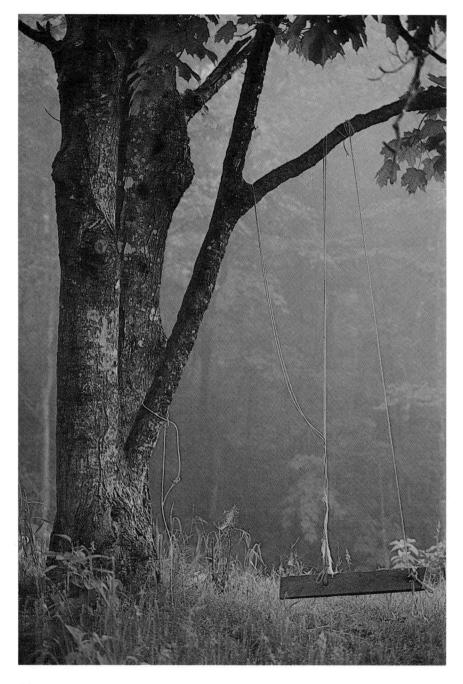

A memory of childhood, or nostalgia, which is the theme of the picture, is expressed through the subject matter. The image is very personal, although the theme itself is universal. The item of greatest emotional and visual interest is the swing, even though the tree occupies more space. The soft light, mist, and restrained colour help to establish the mood, which is as important as the swing in calling up the memory of childhood.

The lure of the unknown is suggested by a road that reaches the edge of a picture without suggesting its eventual destination. That is left to our imagination. The longer the line, the stronger the lure. The fact that part of the road is hidden within the picture space also enhances the sense of the unknown, as does the attraction of the reflecting light on the wet pavement. The informal balance of all the other pictorial elements supports the movement, direction, and appeal of the line of the road.

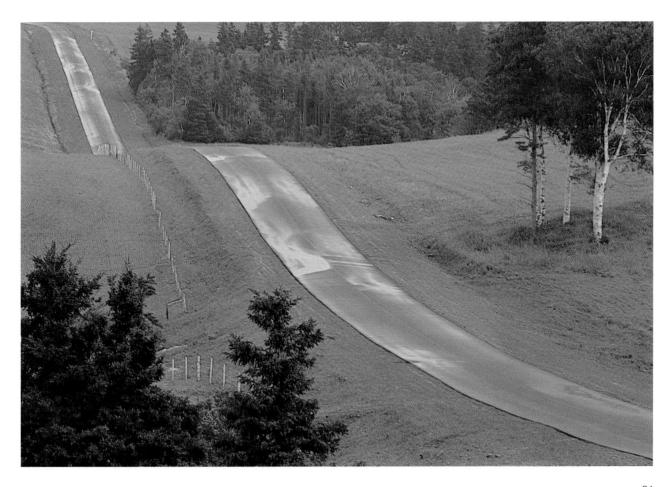

The attraction in this otherwise ordinary composition, for me, was the impact of the rich colours and the neat bands they formed. The soft light from the overcast sky made the colours seem to glow, a powerful effect that moved me to photograph here for an hour. The single evergreen tree, by its dark tone and triangular shape, adds variety. It also acts as a line that links the areas of colour together and gives the composition greater unity.

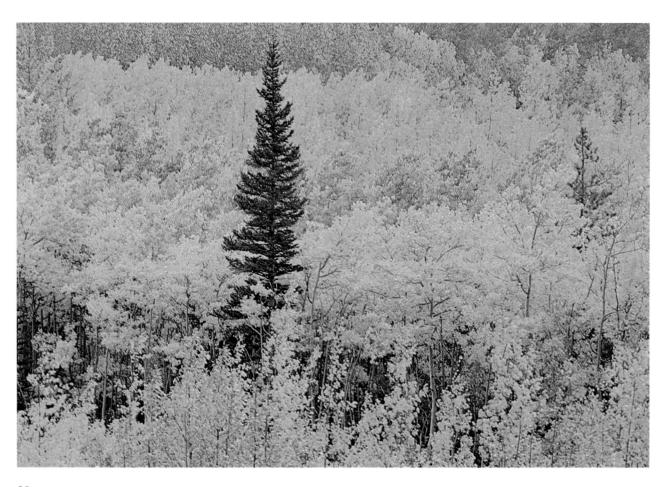

The lighting was that when I composed this photograph, since the sun was almost directly overhead. However, the appearance of the landscape changed every few minutes, as huge, scudding clouds trailed their shadows over the scene. Sometimes they darkened one part of the landscape, sometimes another part. I waited for the moment when the pattern of light and dark areas accentuated the rolling shape of the land, then made this exposure. The contrast between the dark shadow of the cloud and the brilliant yellow foreground affects emotional response strongly, but this passing of darkness and coming of sunlight also has symbolic power. The old barn is important to both picture organization (as a visual resting place) and emotional response.

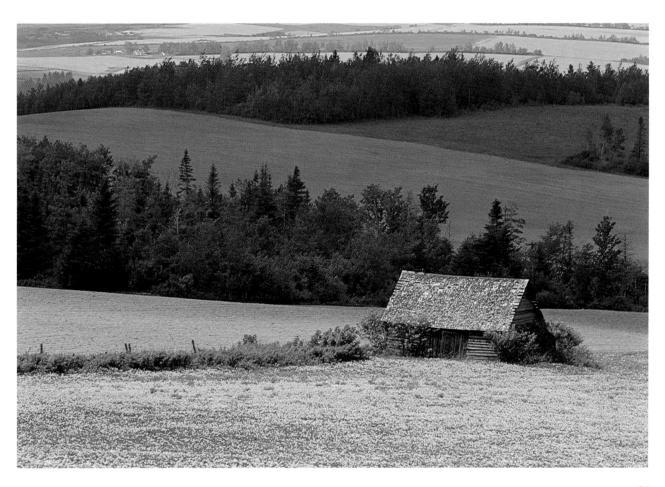

To me this frosty field expressed loneliness and abandonment, mainly because of the dull light, the lack of hues, and the virtual absence of anything that disturbed the overall pattern. For this reason, I placed the small clump of dead flowers in a corner of the picture space, which helps to strengthen the sense of isolation. If I had moved closer to them or used a longer lens to increase their size, they would have become a centre of interest rather than merely a stopping-place for the eye. A photographer should determine what the subject matter expresses to him, in order to use design and camera techniques to support that expression.

Unique properties of photography

Photography is only one of a large number of two-dimensional visual media. Many of the principles of composition used by artists in the other media are equally useful to photographers — they have a universal artistic relevance. Photography also has much in common with three-dimensional media, such as sculpture, architecture, and set design, partly because the perception of depth is a crucial factor in most photographic compositions.

However, the tools of photography — a camera, lens, and film — make it a medium unlike every other, and a photographer has to view his subject matter in terms of what his tools can or cannot be made to do. How do these tools make photography different from other visual media? In what respects is photography unique?

There are at least six fundamental characteristics of the photographic medium that distinguish it from other visual media and that affect a photographer's ability to convey the expressive character of his subject matter. Before we examine the elements of visual design and the principles by which these are controlled in order to achieve effective expression, we should examine photography's unique characteristics; then we will be able to recognize why the natural design of the subject matter is best revealed when the photographer consciously uses the principles of visual design in his composition.

1/ The chief difference between a camera and virtually every other visual tool, indeed the chief difference between photography and the other visual media, is that when you start to make a photograph you

have an already-existing object in front of your lens. In painting, you start with an empty canvas, and you put on it whatever you want. In photography, you can choose the subject matter you want and you can vary your treatment of it tremendously, but you can't escape the fact that you are always confronting some aspect of the physical world that has an existence and character independent of you and your interpretation of it. As Susan Sontag so succinctly states it, "The painter constructs, the photographer discloses." Every photograph is a document of something, no matter how unrecognizable, and no matter what composition and tools are employed.

2/ Photography has the *capacity to render detail* with a precision no other visual medium can match. When we examine photographs, we see many things that our eyes normally miss. In this way, a photograph becomes an aide to visual discovery. The faithfulness to detail and the objectivity of the camera counteract normal human subjectivity and force us to look at physical objects more carefully. This characteristic of photography, like the first, demonstrates photography's intrinsic connection with realism.

3/ A third major difference between photography and the other visual arts is *timing*. A painter or sculptor may doodle or postpone. Not so a photographer. His pace must be geared to his subject matter, and very often is completely determined by it. When the subject matter is in place, or when the light is right, the photographer must act. Recognition of the most expressive moment is of paramount importance.

This means that a photographer has to do his thinking ahead of time – prior to the moment of exposure. This is as true of a picture that a photographer makes on the spur of the moment as it is of one that he carefully plans. Whether you wait hours to press the shutter release or shoot immediately upon confronting a particular scene or circumstance, all of your thinking precedes the instant of exposure. Once you activate the shutter, you can't change your mind. Further thought is irrelevant to making that picture.

This comparison may seem somewhat less apt to the photographer who uses negative film and makes prints, since he has ample opportunity for manipulating the negative after exposing it. Nevertheless, he still has much less room for aesthetic manoeuvering with his print than the painter has, because the content of the photograph and the quality of the original negative determine what he can do in the darkroom. In fact, the person using negative film generally has to treat each negative as a final statement when he exposes it, in order to prevent any lapse of vision or technique that cannot be corrected in the darkroom.

4/ Closely allied to the timing of an exposure is the *speed* at which an exposure is made. A photographer "stops the world." He arrests and holds a fleeting moment in time, usually a fraction of a second. This incredible speed creates both opportunities and problems.

The opportunities that speed provides are most clearly evident in documentary photography. A photographer can produce many pictures of an event while it is happening, or of an object that is moving, whereas a painter or sculptor usually works from memory. Furthermore, the photographs can then be transmitted around the world in a matter of moments. As a form of instant visual communication, photography is impossible to beat.

The danger, of course, is that a photographer will substitute quantity for quality, shooting pictures rapid-fire from many viewpoints in order to increase the possibility of capturing an important moment or a pleasing design. Sometimes this makes sense, but it is often nothing more than a mechanical substitute for visual alertness and scrutiny, and seldom does anything to develop skills. Bracketing is a similar temptation; because several shots can be made quickly, a photographer may vary his lens openings and/or shutter speeds to protect himself against errors in calculating exposures. A safeguard that is sometimes necessary can become a bad habit.

5/ A fifth difference between photography and other visual media is photography's *special connection with chance*, a characteristic to which every photographer should be constantly sensitive. Because the camera does its work so swiftly, a photographer can take advantage of fortuitous events which would slip away from artists in other media. Critics who scorn the "lucky" chance of a photographer are suggesting an accident takes place when a photographer captures a unique event that lasts for only a moment, but it is no accident if the photographer anticipates the event

and knows how to use his tools. In fact, everything that happens contains a large element of chance. Whether wind blows autumn leaves through the air now or a moment from now is determined by physical causes, but from the standpoint of the person making pictures, the timing is purely chance. A photographer has to hope for and prepare for "lucky" chance.

6/ Photography's *dependence on light* is more complete than that of any other medium. Not only is light necessary for exposing film, but also for perceiving the subject matter in the first place. Between the moment of perception and the moment of exposure, a photographer relies on light (its intensity, quality, hue, and direction) to organize the picture space. To mix media for a moment, one might say that a photographer paints with light.

While it is possible to distinguish additional differences between photography and the other visual arts, these six characteristics are the most distinctive. Also, they are the most significant in terms of how a photographer uses visual design. A photographer's dependence on the physical objects in front of the lens limits how he can organize space, but at the same time brings him closer than other kinds of artists to the physical world. A photographer's need to anticipate a particular moment, and then record it instantly, reveals the importance of knowing in advance how composition influences expression. But, more than anything else, a photographer's dependence on light means that form and colour will always be necessary parts of our visual vocabulary, the two basic building-blocks of our attempts to show the expressive qualities of the subject matter and our responses to them.

How a camera sees space

The camera sees some objects differently from the human eye, because we mentally correct distortions while the camera does not.

For example, we think we see a cube like this. But nowhere, except in a drawing, can you actually see the front of a cube as a square and two other sides at the same time.

If you center yourself in front of a cube so that the front appears perfectly square, its depth will not be visible. All you will see is a square. If you shift your position slightly to the right and increase the height of your viewpoint in order to see three sides of

the cube, its front will no longer appear as a true square, because you will be closer to the top than the bottom, and closer to the right edge than the left. The front of the cube will look like this instead.

If you move back to your original position and stare at the front of the cube, you will be able to detect, if the cube is large enough, that the edges of the square do not appear to be straight, but are somewhat curved. They seem to bulge out slightly in the middle, because the corners of the square are farther away from your eyes than the middle of the lines. A square photographed with a lens of sufficiently wide angle reveals this convexity clearly. It looks like the screen of a television set with its slightly bulging sides.

What difference does all this make? Don't we automatically correct our perception? Don't we mentally remove the bulges from the lines that form a square, so we perceive the square as it really is?

Of course we do. However, camera lenses do not, at least not all the time; and different camera lenses see space in different ways. Human perception of space is, to a considerable extent, a learned response. When you stand in front of a tall building, you "correct" the converging lines as you look upward (unless the convergence is too extreme). By correcting the lines, you remove the visual element of perspective, which suggests distance; yet you still know that the top of the building is farther away than the bottom.

When you examine a photograph of the tall building, you see the difference in perception between the camera and the photographer. Most camera lenses do not correct the lines; what they record on film is often not what you see, or think you see.

As a photographer, you must examine the picture carefully through the viewfinder in order to preview what the camera will record. You must be sensitive to any elements that will not be recorded as the eye perceives them. Then you can consider whether or not they need to be corrected and, if they do, how to go about doing it.

It is impossible to overemphasize the importance of careful previewing, if you are concerned about good design in your photographs. The camera not only may see space differently from you, but also may see it in far more detail. You see subjectively, but the lens is objective. It doesn't pick and choose what is important, but shows everything in its field of view.

You may see a scene like this in your travels. Instead of taking only a quick snapshot, why not pay careful attention to design and make a photograph that will really capture what you saw and felt. A wide-angle lens can be a useful tool when composing landscapes, if you use it to include important material in the foreground to provide scale and perspective, such as the white rocks here. These rocks also repeat the general shape of the mountain and give the picture balance. The delicate reddish-pink of the alpenglow is more in keeping with the mood of the calm lake than was the more intense red that occurred moments later.

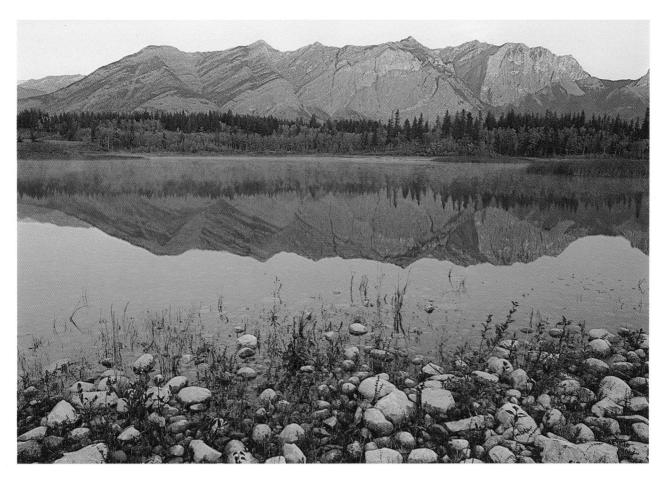

You can learn the characteristics of good visual design by studying and photographing familiar objects around your home. This photograph illustrates at least three points: 1/ the importance of simplicity and dynamics, 2/ in monochromatic pictures, composition depends entirely on the placement of tones, and 3/ the "real" subject matter of this picture is not its label - snow on a shaded windowsill - but the visual elements - shapes and colour.

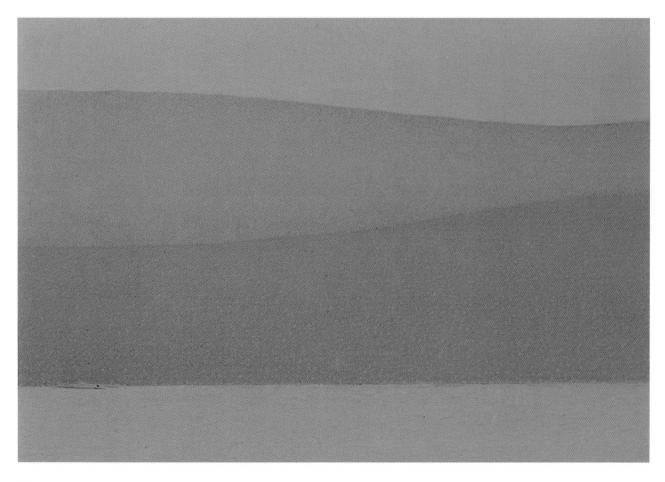

One of the unique characteristics of the camera is the speed at which it can operate. A photographer who wants to record a precise moment depends on this speed; his sense of timing and a camera's speed are partners in visual design. I shot this photograph at 1/15 second to record water that was moving swiftly. The blurred result shows a calm, yet restless, sea.

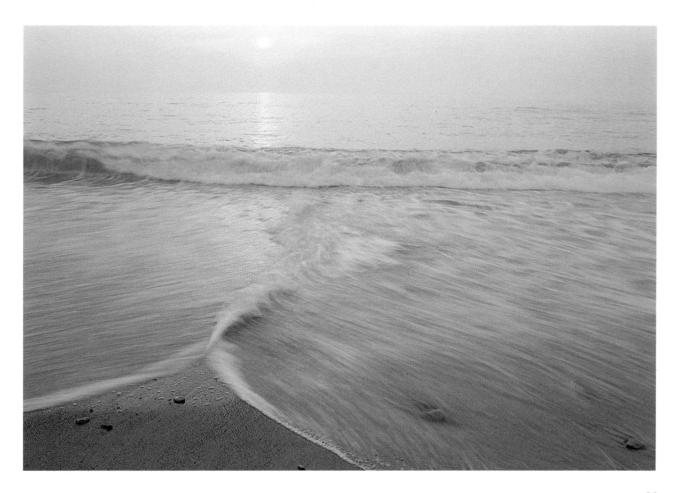

Few endeavours will be more helpful in improving your sense of good visual design than abstracting important visual components, such as shape, line, and texture. In this photograph I find it easy to respond to the design of the subject matter without thinking about what it is. Is the shape any more or less dynamic if you know you are looking at a deposit of industrial sludge, or a sand bar, or part of a puddle? Do the textures or lines change whether or not you are told this is an aerial photograph or a close-up? Not knowing what the subject matter is may help you to enjoy the form and colour as things-in-themselves.

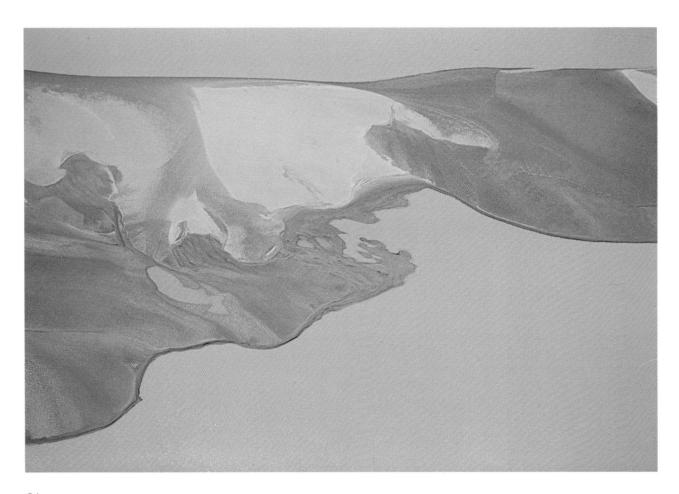

This is a photograph of both a giraffe and its environment, and even though the habitat occupies almost the entire picture space, the animal remains important. Notice how small the giraffe is in the overall design. The smaller a point of difference or contrast, the more isolated or unusual it seems and, as in this case, the more it stands out. An uncompleted movement, which implies that an action will be completed, always adds dynamics to a composition. If the giraffe had reached the dark tree, the whole scene would seem static. Timing is an essential ingredient of good visual design.

All good visual design brings order to a composition. How was order achieved here? I/ The camera position puts the sun on the left, producing side lighting and thus the shadows. 2/ The parallel lines of shadow on the snow create a dynamic composition by moving our eyes across the picture. 3/ Strong black lines of tree trunks were included at the top to act as a visual stopping-point. They ensure that our attention remains in the picture space. 4/ Simplicity is achieved by including only what is needed to give order to the picture. Any additional objects would add clutter, and reduce the pictorial impact.

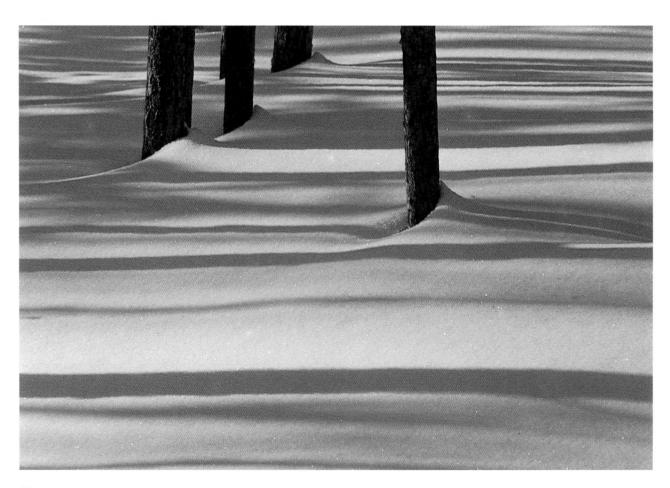

Another exercise in fantasy! I saw the legs of a confused elephant lost in a New Brunswick forest. Since elephants seldom wander so far astray, I didn't want to embarrass this one by showing the look of anguish on its face. That was why I gave such prominence to the foreground. Because every leaf is in sharp focus, attention is drawn to the carpet of green. I can almost hear the elephant plodding around in it as quietly as possible.

This image plays tricks with your eyes and your emotions. At a quick glance, you may see the area above the trees as clouds which fan upward. However, with a closer look you will see the "clouds" for what they are - a massive, glacier-like formation of ice and snow which seems to be pushing relentlessly downward, crushing everything in its path. The trees are being swept down into a vortex. Notice how your emotional response changes when you perceive the heavy ice rather than the clouds, the downward rather than the upward movement. Lines, shapes, and their direction have expressive qualities which influence our response.

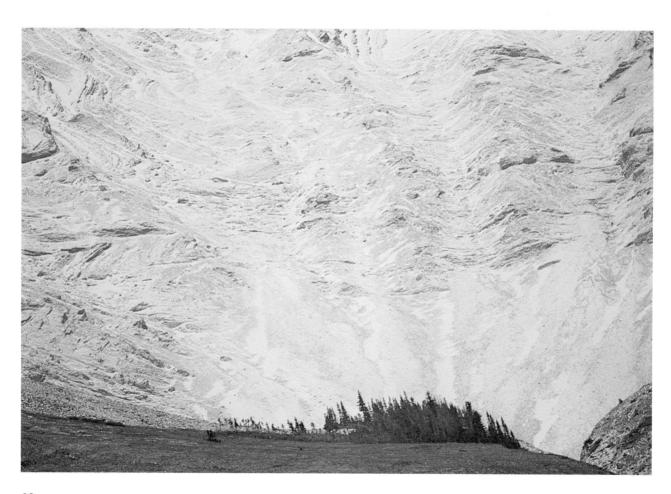

These rays of sunlight streaming through trees can be seen as a strong symbol of exhilaration and hope – feelings that light, bright tones often convey. A photographer who wants to express this euphoria will pay careful attention to exposure, probably overexposing slightly to lighten the scene.

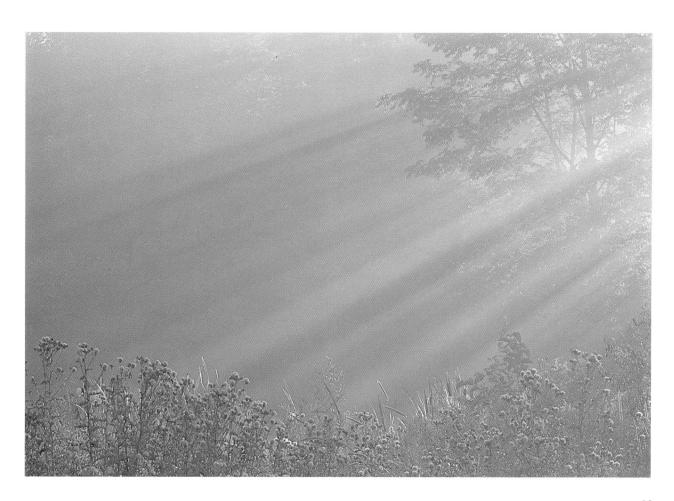

Without the strong side lighting, this composition would be much less dynamic, and our response, weaker. Notice the importance to the overall balance of the design, of the flowers in the lower right corner. If they had not been there, the entire picture would have had to be recomposed. I exposed for the green highlights, since they are about middle grey in tone. This meant that the dark tones and the highlights would remain as they were in the scene.

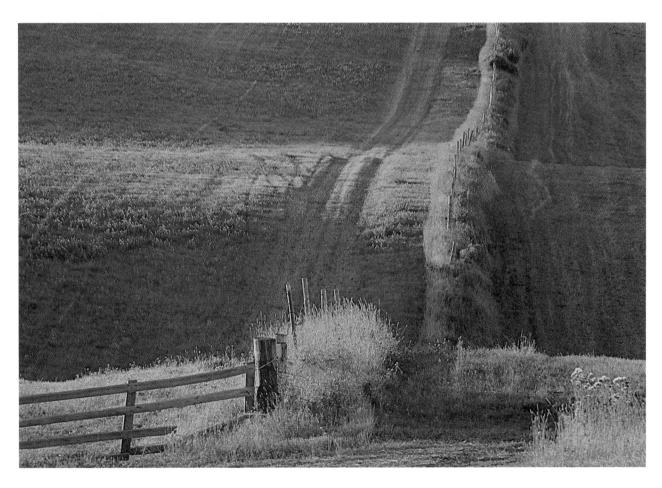

One July afternoon I crawled around in a meadow for nearly three hours, looking at flowers from ground level and making many formal nature studies of the plants that were blooming at the time. Suddenly I had a crazy idea. I decided to examine the plants from the viewpoint of a small animal, rather than that of a human. In my new role, the plants often seemed frightening, especially when viewed through close-up equipment. When you change your perspective, your perceptions will be altered - in this case the unopened vetch blossom becomes a claw; another bud, a hawk perched on a branch.

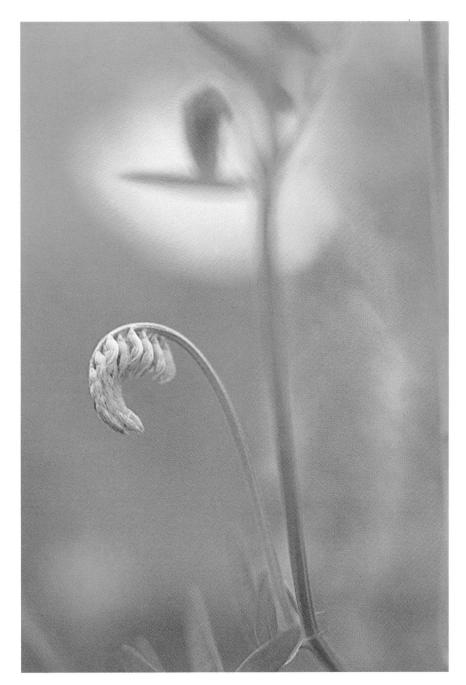

Landscapes and other scenes are among the most difficult photographs to make successfully. Often we are overwhelmed by the mood and complexity of the subject matter to the extent that we miss the design that stimulated our emotional response in the first place. In this image the key elements in the design are the three horizontal spaces – a dark central bar, and a lighter one above and below it. The dominance of horizontal shapes is strengthened by the wake of the boat, which produces a feeling of restfulness. This is reinforced by the soft light. The lighthouse and radio mast of the boat provide vertical thrusts that tie the three horizontal spaces together and, along with the implied movement of the boat, prevent a sense of complete rest.

Thinking about visual design

Each level of visual thinking has its own special tools. In order to observe, you use your eyes. In order to imagine, you depend on your memory. In order to express your subject or theme clearly, you employ good visual design.

A photographer works with two kinds of design – the design he observes in his subject matter, and the design he creates in his photograph by the way he arranges the subject matter. By carefully observing subject matter, a photographer not only understands what it expresses, but also recognizes how the design of the subject matter makes that expression possible. Then, he uses good composition to support the natural or inherent design of the subject matter, so the subject or theme is clear. When a photograph is well designed, you can appreciate the natural design of the subject matter and understand what it expresses. You get the feeling more readily. You are not diverted by unnecessary details or led to incorrect conclusions.

Assuming you are using good building materials, a well-designed car or a well-designed photograph works properly. It does what it is supposed to do. Poor building materials (out-of-date film, incorrect exposure, bad processing) don't change the calibre of design in a photograph, but they do prevent it from performing as it should, just as a flat tire prevents a well-designed car from operating. So, it's always important to remember that, while learning the craft of photography won't produce good visual design, a knowledge of visual design needs to be reinforced by a knowledge of photography's materials and techniques.

In short, everything is connected. Effective expression depends on good visual design; and good visual design depends on careful observation, imagination, and the proper use of tools and techniques.

Design should not be confused with ornamentation – there is a big difference between them. Ornaments are frills or extras which, like good design, may be pleasing to view, but which draw attention to themselves and away from the subject. Good visual design draws attention to the theme or purpose of a photograph, and is necessary to expression.

A photographer should be keenly aware of these distinctions, because it is all too easy to decorate a photograph with things you like, but which obscure its theme. For example, are the flowers on the table necessary in the portrait of your mother? Do they reveal something important about her? Or, do they draw attention away from the twinkle in her eyes? Are the flowers essential to the visual design, or are they ornaments? A truly well-designed picture would include the flowers only if they add needed pictorial balance or make a statement about your mother.

In thinking about visual design, always keep the subject or theme of your photograph in mind. By doing that you will select subject matter that is compatible with the subject and arrange it in ways that make the subject clear. Good visual design is based on the belief that 1/ the subject is what you want to communicate, 2/ the natural design of the subject matter reveals the subject, and 3/ the photographer's visual design or composition should support the design of the subject matter, so that the subject is clearly expressed.

Elements of visual design Form

In photography there are two basic elements of design – form and colour – on which all visual expression depends. Both form and colour are created by light. Let's begin with light.

LIGHT

Light creates form – the *shapes, textures, lines*, and *perspective* in an object – in two ways. In black-and-white or monochromatic pictures it is the contrast of tones – the degrees of intensity of light – that establishes form. But where two or more colours are present, colour contrast also helps to unlock the shapes, textures, and other components of form. This chapter is about organizing the components of form effectively. (The other basic element of visual design, colour, is discussed in depth in the chapter that follows.)

The components of form are influenced by the quality and direction of light. The *quality* of light has to do with its harshness or softness. Harsh or direct light emanates from a point-like source, like the sun in a clear sky or an unshaded light bulb. It accentuates contrast and, depending on the direction from which it comes, may increase or reduce texture and the sense of depth. Soft light occurs when the source of illumination is obscured and the light is diffused before it reflects off the subject matter. Cloudy days give soft light; so does a flash that is "bounced" off a ceiling, rather than being aimed directly at the subject matter. Soft light tends to reduce contrast, because tonal differences are less abrupt.

Shapes, lines, and textures may seem less clearly defined.

The *direction* of light also affects the components of form. Soft light has no particular direction; it is indirect, and seems to come gently from all directions. Harsh or direct light is said to have three basic directions, front lighting, side lighting, and back lighting.

Front lighting occurs when the light falls on the part of the subject matter nearest the camera. Front lighting can be dramatic, especially when it causes strong contrasts. However, this angle of light may hide shadows, reducing perspective in some front-lighted pictures.

Side lighting occurs when the light source is to one side of the picture area, making shadows fall across it. Side lighting is usually exciting, because the shadows it creates provide contrast and often appear as lines. Textures tend to stand out clearly.

When the light enters the picture from any corner (halfway between front lighting and side lighting, or between side lighting and back lighting), many of the characteristics of side lighting are evident.

Back lighting occurs when you are facing the light source, and the light illuminates the back of the subject matter. This is strong, dramatic illumination, because it often produces abrupt and extreme contrast. Back lighting delineates shapes and increases the sense of depth by making shadows stretch toward you. Back lighting helps to create simple, graphic pictures.

LIGHT AND SHAPE

Light creates shapes in two ways: 1/ by establishing areas of tone that contrast with adjoining or surrounding areas, and 2/ by producing a halo or rim-lighting effect around objects, thereby delineating their shapes. The first way is very common, and occurs regardless of the direction of the light. The second way is less common, occurring only when the photographer is facing the light source.

There are three primary shapes: the circle, the square, and the triangle. Just as all secondary colours are blends or distortions of the three primary colours, so all secondary shapes are deformations or arrangements of the primary shapes. A keen observer will *remove the labels*

from objects and view them as shapes. He will be arranging circles, ovals, and rectangles, not trees, faces, and buildings – and find good composition much easier to achieve.

All shapes are two-dimensional, such as a square, a circle, the silhouette of a tree, or the outline of a cup. On paper or film, shapes are flat representations of objects that are usually three-dimensional. In real life every three-dimensional object has as many shapes as there are positions from which it can be viewed. For example, a square in a photograph may have been a box, a building block, or something else that had thickness.

Shapes provide significant information about subject matter when the shape you see reveals the function or behaviour of the subject matter. For example, it's quite possible to see and photograph a circle, and not know if the subject matter is a globe or the bottom of a tea pot. However, the shape of a tea pot viewed from the side, showing the handle and spout, gives much more information about the function of the pot. If the function of an object in a composition is important to our understanding of the composition, a photographer will provide us with a shape we recognize. If the function of an object is unimportant to the meaning of the picture, a photographer may look for or create a new shape that is important. He can do this by changing the position of the camera, by changing lenses, or by throwing the original shape out of focus. For example, by standing at the base of a tall building and using a wide-angle lens, he can make us perceive the rectangular facade as a triangle.

LIGHT AND TEXTURE

Even though a photographer cannot reproduce the texture of a surface – granular, jagged, slick, and so on – on film, he can evoke the sense of it for us. He can engage our tactile sense and make us "feel" as if we can feel texture in a photograph.

More than anything else, the direction from which light falls on the subject matter influences the photographic rendition of texture. Generally, side lighting reveals the texture of a surface more than front lighting or back lighting, but often a light direction somewhere between

side and back lighting accentuates it best. You may have noticed this with snow. When the light enters the picture space from an upper corner and streams across the snow, it creates extremely tiny shadows on the nearest part of each crystal, which we perceive as surface roughness. This lighting also creates sparkling effects which increase the feeling of texture. Soft, indirect lighting virtually eliminates all appearance of texture in snow, since it causes no shading or sparkling.

LIGHT AND LINE

Strictly speaking, there are no true lines in nature, because lines are defined as being one-dimensional; they have length, but neither width nor depth. Nevertheless, we use the term in photography when referring to many thin shapes. Shadows often function as lines in a picture, as do objects such as waves, grasses, telephone poles, and so on. All lines are created by either tonal or colour contrast. Usually, the lines are simply lighter or darker than surrounding space.

Lines have *length* and *position* (horizontal, vertical, and oblique). They give *direction* (that is, they move our eyes and our minds across picture space), and they *create shapes* (as in the photograph on page 53). Because of these properties, lines have great expressive power. As you look at the photographs in this book, you will notice in many that the position, direction, and length of lines are basic to both the visual design and to your response.

The skilful use of lines – both in number and position – helps to make compositions simple and dynamic. The fewer the lines in a composition, the simpler it tends to be, since the viewer's attention is not drawn in conflicting directions. However, a multitude of lines can sometimes form a good composition when they work together to give a sense of unity. For example, several parallel lines may produce an impression of movement more successfully than can a single one.

A straight horizontal line suggests stability and restfulness; make it curve or undulate and the suggestion of restfulness and ease is even stronger. A vertical line can indicate formality and stiffness, but may also give a feeling of strength or power. An oblique line brings life,

activity, and movement to a composition, which is why oblique lines are often useful in pictures of people and nature. The oblique position is the most dynamic one because subconsciously we regard it as being knocked out of a more formal vertical or horizontal alignment. Anything that seems distorted or out of place calls attention to itself. Long, oblique lines are usually much more dynamic than short ones. Any composition that contains only a few long, straight lines — no matter what the direction — is likely to have a pronounced visual impact.

Curved lines are usually weaker than straight lines, but just as vital to visual design. Because they don't move directly to their destination, they suggest that the viewer should also go more slowly, maybe even wander a little.

Lines need not be visible in order to be perceived to exist, so we can speak of both *actual* and *implied* lines. For example, if there is a large dark object in the lower left corner of a photograph and a small dark object in the upper right, we imagine a straight oblique line connecting them. This is an implied line. Similarly, a solid black shape on a white surface, or a human profile have no actual contour lines, but we may still refer to their contours implying that the lines are there. Genuine contour lines occur naturally only with back lighting, which outlines the shape of an opaque object by illuminating its rim. A back-lighted sheep in a dark meadow is an excellent example.

LIGHT AND PERSPECTIVE

Although a photograph is a thin piece of film or paper that can be said to have no depth, the illusion of depth, or perspective, is easily created. In fact, it occurs naturally owing to the ways that the intensity, quality, direction, and colour of light illuminate subject matter.

1/ The intensity of light varies within the picture area, and this contrast aids our perception of depth. A light object will tend to appear closer than it actually is; a dark object will appear to be farther away. However, there are some important exceptions. For example, a series of hills or mountain ranges appear progressively lighter in tone the farther away they are, due to atmospheric haze, which reflects light. Also, a

small area of dark or light tone will appear to come forward when surrounded by a strongly contrasting tone. The amount of contrast, the position of tones within the picture space and in relation to other tones, and the size of the area occupied by particular tones are all important to the rendition of perspective.

2/ The quality of light affects perspective. The more direct the light source, the harsher the illumination, and the more abrupt the tonal contrasts within the picture. Harsh light enhances depth perception. For example, if the surface of an object is rough, the texture is likely to be shown more realistically when illuminated by harsh, direct light rather than by soft, indirect light. The soft light of a cloudy day or "bounce" flash eliminates shadows that create perspective.

3/ The direction of light has a very strong influence on perspective. Front lighting tends to flatten perspective by eliminating tonal contrast, because the shadows may all fall behind the subject matter. Back lighting can suggest perspective by creating shadows that provide both contrast and lines, which in turn imply distance. However, in some situations, back lighting can eliminate perspective. For example, a human face becomes a two-dimensional silhouette when it is backlighted, if tonal variation is obliterated within the face itself, which becomes all black. Side lighting creates perspective with shadows that accent texture and provide tonal contrast. However, if you are photographing horizontal bands of shadow - created, say, by a row of trees - you will sense depth only if the shadows become progressively narrower from foreground to background. In other words, the diminishing size of the shadows is as important as the side lighting that caused them. The strongest impression of depth is created by light that enters the picture space from any corner, because it causes the longest oblique lines, as shadows. Oblique lines often appear to lead from foreground to background, or the other way around, thus suggesting depth. 4/ Colour affects depth perception. Under daylight conditions, warm colours seem to come forward; cool colours seem to recede. From the same distance, a bright red object will seem nearer to the viewer than a bright blue one. Also, saturated hues (red) will seem to be closer than the same hue in a less saturated condition (pink).

PERSPECTIVE AND OTHER VARIABLES

There are other variables that influence the creation and control of perspective. Although they are considered here apart from light, they may be affected by the intensity, quality, colour, or direction of light.
1/ Sharpness. Clearly defined or outlined objects will seem closer than objects that — because of focus, haze, or other natural factors — are not as sharp. For instance, a leaf in focus usually seems nearer than one that is out of focus — even when the out-of-focus leaf is actually the closer of the two. It is sometimes difficult to determine relative location, and optical illusions may occur, as out-of-focus objects in the foreground seem to recede.

2/ Size. Generally speaking, the larger an object is, the nearer it seems to be, especially in relation to smaller objects of identical, or similar shape. The converse is equally true, of course – the nearer an object is, the larger it seems to be. These perceptions are based on what we know from living. Relative size, or scale, suggests distance very strongly indeed, and it is difficult for a photographer to find a situation in nature where this does not occur. Sometimes, however, a photographer will want to introduce an object into the picture in order to add scale and increase the sense of depth. If the prairie road disappearing into the distance does not give the intended illusion of depth, the photographer may wait for a car to appear on the distant horizon. The tininess of the car "corrects" our perception. This is a good technique as long as the added object does not destroy the theme of the picture. A person in a wilderness scene may add needed scale, but may also destroy the sense of wilderness. 3/ Placement or location. The lower half of a picture tends to command more attention and seem nearer than the upper half, especially in photographs that have a horizon near the centre. So, objects located in the lower half usually appear closer than those in the upper half. This, too, corresponds to real life - near objects are usually lower in space than far objects.

Naturally, an object that is located in front of another object will appear to be closer, because it is closer. We perceive this even when the foreground object is smaller than the one behind it. Overlapping is often a key factor in creating perspective.

4/ Obliqueness. Oblique lines appear to be unstable, rather like horizontal or vertical ones knocked out of line. They make a composition appear dynamic by adding tension. Tension suggests movement, and movement suggests space through which to move. Oblique lines also lean forward or backward, although on the flat surface of a photograph an oblique line can only point upward or downward. We simply transfer what we observe in real life to our understanding of space in a photograph. This adds to the illusion of depth in a picture.

Light, deformation (see pages 123 and 124), and the other variables all affect how you perceive depth in photographs. But you do not have to be concerned about them all the time; perspective generally takes care of itself. Only when you feel that the sense of depth is misleading or that a picture could be improved by increasing or reducing perspective, should you employ the techniques I have mentioned. Try examining some of your photographs to see how changes in light, deformation, and other variables could have improved perspective. However, don't let the abundance of information on perspective overwhelm you, or inhibit your photography. Use it with confidence, and only when you have to.

ANOTHER LOOK AT FORM

Form, in the sense of general appearance, always suggests an idea or concept from which a particular object gets its appearance, or to which it is closely related. For instance, the general appearance of an oak or an elm is "tree." "Tree" or "tree-ness" is called a perceptual concept — it is the form of all oaks, birches, spruces, pines, and other trees. The general appearance of an object also refers to more intangible concepts. For example, some people speak metaphorically of a tree's strength and a flower's fragility. While these concepts may be said to have a beginning in the perceptual concept, or form, of a thing, they are nonetheless much more abstract than "tree-ness." In fact, this intangible characteristic of the subject matter — strength or fragility — may also be called its form, and may be the theme or subject of a photograph.

Elements of visual design Colour

In black-and-white photographs, composition and emotional impact are determined by form alone — shapes, lines, textures, and perspective. All these are created by tones. In colour photographs, form usually establishes the structure of the composition, while colour usually has the greater impact on our emotions. We tend to identify physical objects by their form, and to like them or dislike them for their colour.

Think of building or buying a house. Form is the structure of the building — its frame (foundation, beams, supports) and its general appearance. (Is it rectangular? Does it have a flat or peaked roof?) Colour has nothing to do with the stablility and sturdiness of the house, but does have a significant influence on whether or not you want to live in it. Both the colour of the exterior and the colour scheme of each room will help you to decide. Therefore, in the total configuration of the house, colour has to be regarded as a major element of composition. It should be used in ways that will be in keeping with the form of the house and that will affect your emotions in a positive way.

COLOUR AND EMOTION

The colour temperature of light (its warmness or coolness) affects our moods, sometimes dramatically. Cool light, such as the bluish illumination of the sun at noon, seems uninviting, harsh, almost too revealing, while the warm light just before sunset soothes us.

Most people respond readily to bright, saturated hues, and are aware

of their responses. However, the influence of colour is often very subtle, and many people are not aware of their reaction to muted colours. A photographer must be sensitive to both bright and muted colours in order to stimulate or control emotional response to his subject matter.

One fascinating aspect of colours is that they symbolize so many different emotions. For example, "He's yellow" suggests cowardice, and "She's blue" implies depression. A particular colour may symbolize different emotions to different groups or cultures. White is a symbol for virginity and cleanliness in many cultures; in others, it represents death. Both black and white lack hue, which makes them appropriate symbols for death.

Our emotional response to colour determines, to a large extent, what we photograph; some colours attract us, others repel. Very often colour raises, however unconsciously, the two basic questions necessary for making good compositions – what theme does the subject matter express, and how? It is important to realize that we often regard the first question as being about emotions (delight, sadness, tranquility), while the second concerns factual explanations (for instance, tranquility is suggested by the presence of light tones, pale hues, and softly curving horizontal lines). If we want to alter the mood of the subject matter, we are likely to alter the colours of the picture (by adding a coloured filter, changing the time of day, using another type of film, etc.); but if we want to reorganize the composition of the subject matter, we will usually alter the components of form (by changing camera position, or lens, etc.)

COLOUR AND TIME

The colours in your subject matter also express time. A red leaf says autumn; a field of orange-pink grass tells us the sun is setting; a cool, pale bluishness says a summer sun is high in the sky; while a deep, rich mauve is unmistakably twilight. As well as time of day and time of year, colour helps reveal time of life. Although we don't need colour to recognize a person's age, it can support the suggestion of other visual elements. For example, a ruddy complexion suggests youth, and we know a weed is dead when it is brown.

COLOUR AS A THING-IN-ITSELF

The colours in your subject matter will also have significance in their own right. The old saying "a rose is a rose is a rose" might be modified to read "red is red is red." No satisfactory theory has ever been devised to explain the power of red, or any other hue. We could almost think of colour as subject matter itself, rather than simply as a characteristic of subject matter.

If we combine the red hue with the shape of a tree, we have a maple tree in October; but it is the same tree we walked by a hundred times during the summer – without photographing it. Now we photograph it because it is red – but why? Why do we photograph red trees, red boats, and red sunsets? Effective visual expression often depends on our understanding that the actual subject matter is not necessarily a situation or an object, but rather can be forms, colours, or certain qualities found in the subject matter. The situation or object is only a vehicle for bringing us the real subject matter – perhaps the colour red, and whatever it evokes in our emotions.

COLOUR AND COMPOSITION

A photographer controls colour by both selection and technique. For example, you can add, change, or eliminate colours by altering your camera position, by varying the time of day, by extending or reducing the duration of exposure, and by using filters or special darkroom techniques. You can diffuse, mix, or soften colours by throwing them out of focus and/or by using a shallow depth of field. You can also control colour by where you locate it in the picture and how you vary the size of the hue areas.

First, ask yourself "Why am I making this picture?" When you have identified the reason — let's say to show the passing of autumn into winter — you will be able to make sensible judgments about colour. If fall is nearly over and winter has almost arrived, you will realize that subdued or drab colours must dominate the bright colours in a scene — visually and mentally. So, you choose subject matter that expresses the theme by its colour — perhaps an expanse of grey-brown tree trunks

and a few remaining frosted red leaves on the tip of a raspberry cane.

Now you must ask yourself questions about the placement and size of the colours. "Where do I place the red leaves within the picture space?" "How large or small should they be in relation to the tree trunks?" The answers will not be based solely on colour relationships. The shape of the subject matter, and the tone of the red leaves and of the grey-brown tree trunks must also be considered. By placing the red leaves in a lower corner, then filling the remaining ninety per cent of the picture space with the grey-brown expanse of trees, the leaves will appear to be overwhelmed. The colour pattern will express your theme that autumn is nearly over.

Focus, depth of field, and lighting will also influence the colour rendition, and contribute to the way we perceive the completed image. For example, if you focus on the raspberry leaves and use a shallow depth of field, perhaps f/2, you will emphasize the leaves at the expense of the tree trunks. Can you do this without contradicting the theme? What will happen to your understanding of the image if you choose a greater depth of field, perhaps f/11 or f/16? An increase in the depth of field will tend not only to sharpen the background lines, but also to intensify the grey-brown hue by making it less diffused. How will the greater depth of field affect your emotions? What will the effect of side lighting be? Back lighting? How will your perception of colour change if you shoot on a cloudy day? How will your mood change?

There is no "correct" way to render the colours in this picture, but some ways lead to more effective expression than others. Let your technique be determined by what needs to be expressed rather than by technical goals such as a search for colour harmony. Seek to balance the elements. Keep the theme or subject of your photograph clearly in mind, and try to use colour to support the theme.

Harmonious colours convey serenity, peace, and inaction. If the colours present in your subject matter express such a theme, you may want to emphasize the harmony by using soft, indirect lighting. If the colours suggest life, movement, and change, you may want to increase the tension by using oblique lines. Your technique should always be based on what is being expressed, and never be imposed upon it. In this

way you will produce a unified impression with clear expression.

In all colour photographs, we perceive colours in relation to the other colours that are present – that is, in relation to their hue, saturation, brightness, location, and relative size. A composition dominated by primary hues (red, yellow, and blue) has great stability; any secondary hues (such as orange and violet) that are present act as enlivening agents and prevent boredom. A composition dominated by secondary hues has less stability because we perceive the hues as unstable – that is, tending toward the primaries. This instability creates visual tension, which helps to make the composition more dynamic.

Some compositions may contain only primary hues. If the primaries occupy areas of nearly equal size and are fully saturated, the result is bold colour. Subtlety is absent, and the sense of stability is very great. In order to add tension, the relative size of the primary colours (or their brightness, or saturation) will have to be altered by changing camera position, or lighting, or by some other technique. A visual design that lacks one or two of the primaries allows the remaining primaries to affect our emotions very strongly.

Other compositions have only secondary hues. Generally speaking, any photograph that lacks primaries has less tension than if one or more of the primaries were present. Compositions with two or three secondary hues of about equal tone and saturation (perhaps light brown driftwood on silver-gray sand) tend to be serene.

If a photograph contains only one hue, for example, a golden-orange mist at sunrise, that is called monochromatic colour. In such a picture, the composition is determined entirely by the tones — in other words, the different values within the hue become very important.

Ideally, a photographer will seek a good balance of form and colour for every picture he makes. He will use the part of his brain that differentiates and organizes, the part that responds to the different aspects of form; but he will also use the other part that, in a sense, is geared to expression and responds more directly to colour. A good way to begin is to examine some of your old photographs. Try to determine the elements of visual design that have influenced you the most. If you are a colour photographer who has paid too little attention to form,

make a series of pictures of monochromatic subjects (a lush green meadow, a tangle of brown bushes in April or November, drifts of snow or sand). Study the tones and organize your composition around them. Then, later on, try some black-and-white film. If you are a black-and-white photographer who seldoms shoots colour film, why not make a move into colour by applying your knowledge of form and tone to one-colour situations. Working with muted, monochromatic colour is excellent training for both black-and-white and colour photographers.

There is great danger of becoming confused by too much explanation and too many examples. What counts is actual working with colour, not theory. Most of what is important you can discover on your own, and learn to apply by common sense, not formal guidance. In fact, a lot of theory will make sense to you only *after* you have been working with colour film for quite a while and have personal experiences to which you can relate the theory.

Principles of visual design

A photographer arranges the various components of form and colour in different ways in order to express the meaning of the subject matter and his response to it. If he depends on fixed rules of composition, he will usually be unsuccessful or achieve only superficial expression, but if he learns the principles of visual design and is flexible in his thinking, he is much more likely to achieve clear and effective expression. In no other aspect of photography are flexibility and intuition so desirable as in the application of the principles of visual design. However, two things are present in all good pictures — order and tension. You can understand order and tension by thinking of *simplicity* and *dynamics*, the two basic principles of visual design.

DYNAMIC SIMPLICITY

It is difficult to over-emphasize the importance of simplicity when making photographs. Simplicity brings order and stability to compositions, no matter how many objects are present in the picture. Abstracting and selecting make simplicity possible.

However, if everything were as simple as possible, life would be very boring. We need to balance order with tension, which brings movement, activity, and a sense of the dynamic both to our pictures and to our lives. Too much tension, however, creates hyperactivity and disorder. So, pictorial composition, like living, always involves balancing tension against order. The ideal to strive for is a combination of the two – dynamic simplicity. Think of a good talk or lecture you have heard. If the

content was organized in a simple fashion and delivered in a dynamic way, the message was clear. That is how it is with effective expression.

ACHIEVING DYNAMIC SIMPLICITY

The five secondary principles of visual design, by which you can achieve simplicity and dynamics, are *dominance*, *balance*, *proportion*, *pattern and rhythm*, and *deformation*, or distortion. These principles are illustrated by the photographs in this book and are discussed in many of the captions. *1/Dominance* means simply that some aspect of the composition influences it more strongly than all other aspects. The dominant part of a photograph is often called the centre of interest. It may be dominant because of its size, colour, location, symbolic value, or any combination of these and other factors.

If nothing larger or brighter is present, a tiny figure in a huge meadow becomes a centre of interest because it is so different from the surrounding grasses. A tall flower that towers over a shorter one of the same hue and brightness will usually be regarded as dominant, even if the blossoms are of equal size — its longer stem leads our eyes through greater distance and holds our attention longer. A bright, saturated colour will dominate a pale, unsaturated one unless the pale hue is small in area and overlaps a large surface of the brighter hue.

Not all pictures require a dominant object, however, and some are spoiled if they have one. This is especially true when all the parts of the subject matter, viewed as a whole, form a pattern or shape that is visually more arresting than any of the individual parts. Think of a small pond covered by hundreds of coloured leaves. The mixture of reds, oranges, yellows, browns, and greens may appear as a tapestry beautiful in its own right. Inserting an old stump as a centre of interest would mean disturbing the pattern. The photograph on page 144 doesn't require a centre of interest. No feature is dominant – the balance of shapes and hues produces a design that is attractive in its own right.

In other pictures the power of the centre of interest needs to be tempered by similar shapes or colours that compete for attention to a limited degree. The visual impact of a brilliant red object can be reduced by the presence of a second red object that is duller, smaller, and placed across the picture from the larger one. This example also illustrates the principle of balance.

2/ Balance suggests dominance held in check. However, balance may be more complex and involve many picture elements. There are two kinds of balance – symmetrical and asymmetrical. These are also referred to as formal and informal balance.

Symmetrical pictures often seem formal and stiff, even static, because everything is organized around a central axis and is in a state of equilibrium. For instance, the photograph of the interior of a church may be perfectly balanced if you stand in the centre aisle and aim your lens directly at the alter. All the shapes and lines on one side of your picture will be the same as those on the other side. In this situation, a symmetrical composition makes sense, because your subject matter is symmetrical and may clearly express the theme you want to convey.

Next, think of a still-life arrangement in which three objects of about equal size (a lemon, a lime, and a mandarin orange) are spaced at equal distances from each other and the edges of the frame. The reason that few people are likely to make such a composition is simply that the relatively perfect balance in the placement seems out of keeping with the subject matter.

Informal, or asymmetrical, compositions are often more dynamic than formal compositions because of the tension between objects of different colour, shape, size, etc. Think of a large shape, perhaps an oak tree on the left side of the picture, that is balanced by a much smaller bush in the upper right corner. If the bush were absent, our attention would be riveted on the oak tree, and we would be very slow to explore surrounding space. The small bush leads our eyes away from the tree long enough to investigate the environment, but we keep coming back to the oak tree since nothing else is as visually commanding.

Every physical object can be said to have tension. We experience the tension between objects when we view a composition. Our normal visual experience is dynamic, because the tension between the colours, shapes, sizes, and location of things keeps our eyes constantly moving. Photographers control tension by the way they balance objects in the

picture space. Good balance means taking advantage of tension without letting the visual pull of any one object get out of control.

Asymmetrical, or informal, balance differs from imbalance. An unbalanced photograph is one that has no overall unity. It may appear accidental, haphazard, and lacking in theme. On the other hand, a well-balanced, asymmetrical composition contains objects displaying both tension and control. Our eyes examine all parts of the picture because of the tension between the objects (caused by their colours, shapes, sizes, locations), but they move according to a pattern carefully established by the photographer. This is a dynamic composition.

Balance may be either physical or psychological. Certain objects or spaces attract us because of their size, shape, and colour. Others command our attention because of what we know about them. A wolf, however small, on your front lawn is more likely to attract your attention than a red maple, no matter how splendid the maple is. Because psychological factors can have as much or more weight than physical ones, viewers' responses to photographs are bound to differ.

Weight and direction are basic properties of balance; both exert a dynamic effect on pictorial composition. Weight refers to the visual or psychological pull of objects, and is affected by their location within the picture (top to bottom, side to side, and the apparent depth of position). Weight is also influenced by colour and size. Red is heavier than blue of equal saturation and brightness; bright colours carry more pictorial weight than dark ones. A large object has more weight than a small one, other things being equal. Of course, every photographer will have observed that an object that is isolated has more weight than one that is not, and that certain shapes seem to have more weight than others of nearly equal size, colour, tone, or texture. Simple shapes, such as a circle or square, often appear to have more weight than complex shapes that may be larger.

Direction is also important to balance. For example, a line that leads to the upper left corner will balance one that leads to the upper right. Such balance can occur when no physical line exists. For example, when a person faces a tree, we understand him to be moving toward the tree. The implied horizontal line will balance the vertical line of the tree.

- 3/ Proportion is closely related to balance, and has to do with the relative size of objects in the picture space. The proportion of space allocated to a major object, in relation to that allocated to a minor one, can determine whether or not pictorial balance is satisfactory. The size of the main subject in relation to its surroundings (foreground, middle ground, and background) will have a strong effect on how we interpret the image. For instance, a snarling dog nearly filling the frame will seem far more threatening than the same dog occupying only a tiny portion of the picture area.
- 4/ Pattern and rhythm are closely related. A pattern is a specific configuration of visual elements, in short, a design. Rhythm is a way to use pattern. A pattern may be repeated at random, but if it is repeated at regular intervals, we speak of rhythm. The regular repetition of any visual element or pattern of elements over a given area affects the way we look at a photograph and interpret it. Rhythm brings both order and a sense of the dynamic to a photograph.
- 5/ Deformation, or distortion, of visual elements creates perspective. (Perspective is the impression of depth in a photograph, or other two-dimensional image.) Deformation does not mean mutilation of a shape, such as cutting a slice out of a circle, but rather an alteration in the overall shape which makes it unstable and increases tension. For example, if you photograph a sphere with a wide-angle lens from a position near the globe, but turn slightly away from it, the globe will appear to be stretched. It will look like an oval, which we will perceive as having more depth than the sphere.

Both camera position and choice of lenses affect deformation strongly, and thus have the power to alter our perception of depth. Any camera position or lens that makes a deformed shape look less deformed will lessen visual tension, increase stability, and reduce perspective. For example, a telephoto lens will appear to flatten perspective more the farther away the subject matter is. A wide-angle lens will appear to stretch perspective more the closer it gets to the subject matter.

To look at it another way, if you switch from a standard 50mm lens to a wide-angle lens *and* move closer to your subject matter, you will increase the sense of depth. If you switch from a standard 50mm lens to

a telephoto lens and move farther away from your subject matter, you will reduce the sense of depth. You can also alter perspective by changing the angle of approach to your subject matter. Here are some examples to show how you can use deformation to create perspective. a/ You might accept photographic deformation (unnatural enlargement) of a person's hand if he is reaching out for money or to greet you, but avoid deformation in an informal portrait by waiting until the hand is closer to the plane of the body.

b/You might want deformation (foreshortening of distance) in a picture showing a confusion of road signs, in order to augment the confusion. On the other hand, in a general record shot of the same area, you would probably prefer a more realistic rendition of the distances between spatial elements.

c/ You should change your camera position, or change your lens, or both, in order to avoid the convergence of the lines of a tall building, if the effect of the convergence will distract the viewer. However, you might welcome the convergence in a picture showing the moon rising over the building, because the converging lines would form a near-triangle with the moon at its apex, thereby emphasizing the expressive power of shapes. In this latter case, deformation would be perceived as good design. Deformation ceases to be seen as deformation when it forms another basic shape; in this instance the rectangular shape of the building's facade ceases to be perceived as a deformed rectangle and, instead, is viewed as a triangle, as in the photograph on page 139.

Of the five secondary principles of visual design, dominance and balance are the most important for picture unity. When you repeat similar qualities or elements, you establish the *dominance* of a pattern that unifies the whole composition. When you *balance* the influence of dissimilar elements, you accomplish the same thing.

A photographer should resist every temptation to codify the principles of visual design or to create pictorial formulas, because such attempts will stifle intuition, reduce emotional input, and put technique ahead of expression. As you become more familiar with the principles of visual design, you will begin to develop intuition for good design, sensing and responding to the expressive qualities of your subject matter.

Working with visual design

When you are composing photographs, observe the natural design of your subject matter. Good composition is always harmonious with the design of the material being photographed. No other guideline of composition is as important as this one. Specific rules or formulas of composition often violate this guideline. Rules are created when certain approaches or techniques are observed to work well on many occasions. It makes good sense to be aware of the usefulness of such approaches and techniques, but it is a mistake to impose them on all subject matter. Also, reliance on visual formulas may hinder observation and imagination.

Every time you make pictures you have to ask some specific questions to help you decide on your composition. Should there be a centre of interest? If so, what will it be? Where should it be placed? How much of the picture space should the main subject matter occupy? Does it need a base for support? You should answer these and other specific questions by applying your knowledge of the principles of visual design to the particular situation.

Here are some general guidelines which you may find useful in finding your answers.

CENTRE OF INTEREST

A centre of interest is an object that dominates the picture space. Its dominance may be due to its size, colour, shape, or some other physical or psychological factor. Photographers are often concerned about

whether or not to have a centre of interest, and where to place it.

Let's say you want to photograph sand dunes. The sweeping lines, the rippled texture, the glowing browns, and the empty spaces have a powerfully haunting effect which you want to capture in your pictures. If you need a centre of interest to unify your composition, it should come from the dunes, since they are the subject matter. If you are considering a dark rock for your centre of interest, ask yourself if the tone will unify the visual elements in a natural way. Be sure to look for other features, such as a sweeping line or an intense hue, as possible centres of interest. A person in the scene would immediately become the centre of interest because it is so different from the dunes. You must decide whether or not the person adds to or counteracts the haunting effect you are trying to capture as your theme.

General conclusion. The centre of interest should be a natural part of your subject matter, not something added or imposed (except for photographs that are intended to show incongruity or an unusual occurrence).

The placement of a centre of interest must be determined by the theme, the other objects present, and their relationships to each other. You must make a new decision for every composition. *Always avoid a formula*. A rule such as "the centre of interest should preferably be onethird of the way from either side, and one-third of the way from top or bottom" is no more useful than a rule in fashion that decrees "every woman shall wear a size 12 dress." The fact is some women should wear size 12 dresses, and some should not. Sometimes the centre of interest should be in a one-third position; sometimes it should not.

BASE

Not infrequently one hears the comment "This picture needs a base," something for the subject matter to stand on. The remark reveals the normal human perception that things lower down in a composition are more important (have more "weight") than things higher up. When a picture is top-heavy, it makes us feel uneasy. Adding a base makes sense when strong lines (perhaps a row of trees) touch the bottom of the frame and lead our eyes out of the picture space. But having a base makes less

sense if the same lines *also* lead our eyes out at the top, because that movement counteracts the movement at the bottom. A visible base is only one solution to the question of balance, which is probably what the photograph lacks. There are many ways to achieve balance. *General conclusion.* Focus on the need for balance, rather than on one particular method for achieving it.

FILLING THE PICTURE SPACE

Quite often a photographer is told that he should move closer to his subject matter in order to fill the picture space. This is a valid comment if the theme of the picture is expressed primarily through the centre of interest. It is invalid if the theme is expressed by the relationship between the centre of interest and surrounding space. For instance, the immensity of the landscape may be the main theme of a photograph, in which case the centre of interest must be small in order to preserve the sense of great space, as in the photograph on page 21. Many nature pictures are strengthened by keeping the plant or animal relatively small in the picture area, in order to show the habitat. Also, any photograph that communicates the size of a plant or animal in relation to its environment provides us with useful information.

General conclusion. The size of important objects in a photograph (including the centre of interest) should be determined by the theme of the photograph.

FRAMES AND WINDOWS

When we talk of "framing" a scene, we often think of a tree or branches hanging into what would otherwise be empty foreground space. A frame can be useful in two ways: I/ it fills space, and 2/ it creates a sense of depth. When branches overhang a small village, for example, we perceive the village to be farther away than if the frame were absent. Although framing is one of the easiest ways to create perspective, a frame may add clutter to a photograph or become visually compelling in its own right, thereby competing for attention.

General conclusion. Think of a frame as a prop, a visual support for the theme or centre of interest. It should be visually compatible with and draw attention toward the main visual element. A viewer should become aware of the frame after viewing the centre of interest.

When the foreground material or frame completely surrounds subject matter that is farther away, we may refer to the frame as a window, as in the photograph on page 18. Nevertheless, the same general guideline should apply. If a window becomes more important than what is beyond it, a photographer may be wise to photograph it for its own sake. For instance, think of an arch of eroded rock through which you can see a bit of desert. The arch is a window, but it is also the intended centre of interest. If the arch and the desert beyond vie with each other for attention, you may want to eliminate the desert by taking a low camera position and shooting upward to place the arch against the sky.

LACK OF PERSPECTIVE

The world is three-dimensional, but photographs are not. Most photographs give the illusion of depth or perspective, although some are strong designs because they lack perspective. If the shapes in a picture space are visually and emotionally compelling, frequently the best way to strengthen their impact is to remove the element that competes most strongly with them, which is usually perspective. For instance, the shapes in aerial photographs are strengthened by the lack of perspective, as in the photograph on page 94. The use of a telephoto lens at a considerable distance from the subject matter also eliminates foreground material and has the same effect — depth is reduced and shapes are emphasized.

General conclusion. A photographer can strengthen the expressive power of shapes by reducing the power of perspective.

AMPUTATION

Every picture contains subject matter that is amputated by the borders. However, portraits and other pictures of people may suffer because an important part of the body is amputated, such as an arm severed at the wrist or a foot cut off at the ankle. A person near the edge of a picture, facing outward, falls into the same category, because the implied forward line of movement is shortened or amputated by the frame. Amputation weakens composition *only* if it interferes with expression by drawing attention to itself. When amputation is unavoidable, you may want to counterbalance its effect by strengthening the importance of other areas of the picture, especially the side or corner opposite the amputation. For example, a person moving out of the picture space may be counterbalanced by a colour, shape, or tone that is opposite him, and, while less important, is strong enough to exert a visual pull. However, some amputations are desirable. Think of a racing car zooming out of, rather than into, the picture area. Its position indicates the tremendous speed at which it is moving. In the photographs on pages 133 and 136 the amputations are important to theme and composition. The distracting effect of important objects amputated General conclusion. by the frame can be offset. This can be done by placing lines or shapes or colours on the opposite side or corner to establish balance.

TRUE COLOUR

At any given time, the rendition of hues in a scene is affected by several factors — time of day, quality of light, position of hues in relation to each other, and so on. When you decide to make a photograph of a scene, you will then add more variables that influence colour rendition — such as choice of film and length of exposure. The natural variables, together with the photographic controls, make myriad colour interpretations possible. In fact, there is no such thing as "true" colour in our perception of actual objects or photographs of them, so photographers shouldn't worry about it.

What should concern you, instead, is simply "appropriate colour" – that is, colour suitable for the theme and the subject matter that expresses it. On most occasions, the colour already present in the subject matter exerts a strong enough emotional pull to interest you in

photographing it. The colours of a sunset and autumn leaves are obvious examples; and muted colours can exert an emotional influence that is just as strong. It is important, therefore, to recognize consciously the power of colour and, as you prepare to make a photograph, to use both the principles of visual design and camera controls in ways that will maintain the effect or strengthen it. Less often, you will have to manipulate or alter colour in order to reinforce a preconceived idea. Fashion photographers do it all the time – with filters, coloured lights, and props.

No matter how successful you are in producing the colours you want in your photographs, and no matter how appropriate they may seem to you, be prepared for others' reactions to be different from your own. Responses to colour are often very personal.

General conclusion. Colour frequently motivates a person to make a photograph. The photographer should try to identify both the emotion and the colour(s) that motivated him, in order to use colour appropriately in his composition and to choose the photographic controls necessary to capture the same hue in his photograph.

CORRECT EXPOSURE

The quality of exposure may strongly affect the quality of the photograph, and how accurately it records the subject matter, since exposure has such an important effect on how tones (and thus form and colour) are rendered. There is, of course, no such thing as absolutely or objectively correct exposure. A reflected-light meter reads the areas of tones or contrasts in its field of view, and gives shutter speeds and lens openings that average out to "middle grey." If your subject matter is itself middle grey — that is, not dominated by bright or dark tones — then a middle grey reading may give you the exposure you want. To get correct exposure, you must remember to compensate for the light meter under certain conditions. If, for example, there is pure white snow in most of your composition, you will have to "overexpose" or deliberately allow more light to reach the film than the meter has indicated. Otherwise, if you do what the meter says, you will get middle grey snow.

Bracketing is one way of ensuring correct exposure — a rendering of the subject matter exactly as it looks to the eye. To bracket, one simply shoots several shots of the same scene, using different aperture settings and speeds, in the hope that at least one combination will be successful. However, except for those times when you are deliberately experimenting, it is wise to avoid bracketing, and to rely on your best judgement and your common sense. The way to learn is to examine tones in your subject matter carefully until you can recognize them on sight in nearly every situation. You should be able to distinguish what is one, two, or three stops lighter or darker than the "middle tone" in your composition. This takes some practice, and even though lots of practice may never make you perfect, it will help you to interpret what your meter tells you — and interpretation is the first step in using exposure as an element of visual design.

If you learn how to read *objectively* the amount of light reflected from or falling on the different parts of your subject matter, you will then be able to interpret it — that is, to alter lens and shutter openings so the exposure you make will indicate your feelings about the subject matter. If, for example, you want an image to *appear* dark and ominous, except perhaps for a glowing headlight, you will underexpose.

General conclusion. The right exposure for your subject matter depends on both objective and subjective factors. Learn how to read or estimate tones or contrasts in your subject matter. Then use your meter as a guide, but adjust your lens and shutter openings to lighten or darken the tones, in order to get the exposure you want. The choice is always up to the photographer – but the choice demands thought and practice.

SYMBOLISM

All objects, events, and the components that give them form (shape, line, texture, perspective) and colour, may have symbolic value. Symbols may be positive or negative, strong or subtle, but their effect cannot be denied, and a photographer must be sensitive to their influence. This will affect how you compose pictures and how viewers will respond.

For example, think of two identical photographs of a woman in a field

of flowers. In one photograph the woman is wearing a pale pink dress; in the other she's dressed entirely in black. Viewers will respond to the photographs in very different ways, and since the only difference is in the colour of the woman's dress, the difference can be attributed entirely to what each colour symbolizes. The woman in pink will probably be considered happy or serene, enjoying the flowers and fresh air; the same woman dressed in black may seem unhappy or in mourning. The flowers will support either interpretation — happiness or sadness. The photographer can make sure that the viewers will respond in the way he wants by the manner in which he handles a basic photographic tool — exposure. Slight overexposure to lighten the first photograph will visually and emotionally strengthen the mood of serenity or pleasure. Light symbolizes these moods for nearly everybody. Slight underexposure of the second picture will darken the scene and enhance the sense of sadness or mourning.

General conclusion. All objects have symbolic value, as do the elements and principles of visual design. A photographer should use his tools and techniques to strengthen the symbols he wants to emphasize, and reduce the power of those he does not — in order to achieve effective expression.

You may have other questions that confront you in composing a picture. When you do, think of the theme of your photograph and then use your equipment and the principles of visual design to arrange your subject matter in ways that make the theme clear. Improving your sense of good visual design can be an exciting, life-long project.

Study some of your best photographs to determine why or how they express a feeling or capture a mood. Look for choices of subject matter, design, and technique that occur frequently in your images, and ask whether or not they are good choices. Be as objective as you can. Ask what the subject matter expresses and how its natural design makes that expression possible. Then ask if your composition helps to make that expression clear. Are you merely relying on rules or formulas, or are you developing your ability to observe?

When you respect your subject matter and keep working with visual design, you will find yourself developing a personal style that expresses not only the theme, but who you are.

There is usually a good reason for having a head on your shoulders – but not always. If this man had a head, it would draw attention away from the butter in his hand and the cat at his feet – both of which add an informality to a very carefully balanced composition. The overcast sky was fortunate; sunlight would have created strong highlights and even blacker dark tones, which would have spoiled the gentle, informal mood.

A wide-angle lens is often useful when the environment or setting is important to the theme of a photograph. If I had used a telephoto lens I could have filled the frame with the boys and their dog, but I would have lost the place where they belong. The little village contributes to how we feel about this moment. Notice also how the boards in the lower left corner point to the action and offset the strong movement of the road that leads in from the lower right. Using a wide-angle lens simply to get more things in a picture seldom produces effective photographs. Like every other photographic tool, it should be used with a specific purpose in mind.

This child has one of the most beautiful faces I have ever seen. She was hopelessly crippled. She walked with great difficulty, aided by complicated machinery into which she was strapped up to her chest. While I have pictures that show her entire body, the tangle of equipment now seems irrelevant. It was her eyes and her smile that revealed her character and spirit. The most important details of design in the picture are the two oblique lines formed by the child's eyes and lips. The oblique positioning gives a sense of vitality, which is strongly reinforced by the oblique line of the wall rising behind her head.

I saw this elderly lady as passing away from me and my world, so I photographed her through a window clouded by reflections and curtains. The shallow depth of field, which throws the reflections and curtains out of focus, creates a sense of the surreal and unknown. The hand of the woman's friend appears in the lower right corner. By all traditional standards of composition, the hand should not be there, since it looks amputated. Yet it seems strangely appropriate, representing support that may be needed in the present, while at the same time adding to the impression of the world dissolving.

This photograph captures a moment in the life of a child, and suggests innocence. The little girl had withdrawn from her playmates on the beach; she wanted to be alone. She was crying a little. When I came along, she hid her face to preserve her privacy. I quickly made this picture and left. Note that the expanse of rocks and the girl's small space in the composition strengthen the sense of her privacy.

Since all hues are expressive, a profusion of colours may cause conflicting impressions and make a viewer uncertain of his response. A photographer should have a clear idea of what he wants to convey, so he knows when to eliminate unnecessary hues or how to combine several colours to create a unified impression. The hues in this scene – brilliant blue, lively pink, rich green, and pale gold – all contribute to the feeling of summer. The psychological overtones of colour are hard to overestimate, which is why many hues are so often used as symbols.

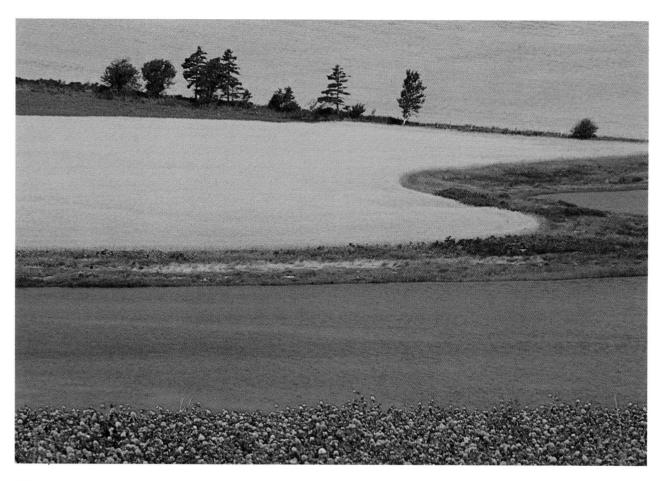

When you have a problem in visual design or technique, try to see how the problem could help you to make a better picture. Three difficulties were converted into assets in this image. 1/ Although deformation, or distortion, of a shape often looks unnatural, it can be used to create perspective, as the long, bright rectangle shows. Perspective can be increased by choosing a camera position near the object and, at the same time, using a wide-angle lens. 2/ If you can't avoid lens flare, use it as a balance for other subject matter or to strengthen your composition in some other way. 3/ Don't be afraid to point your camera at the sun for dramatic effects. The smallest lens opening may give you a star-burst effect.

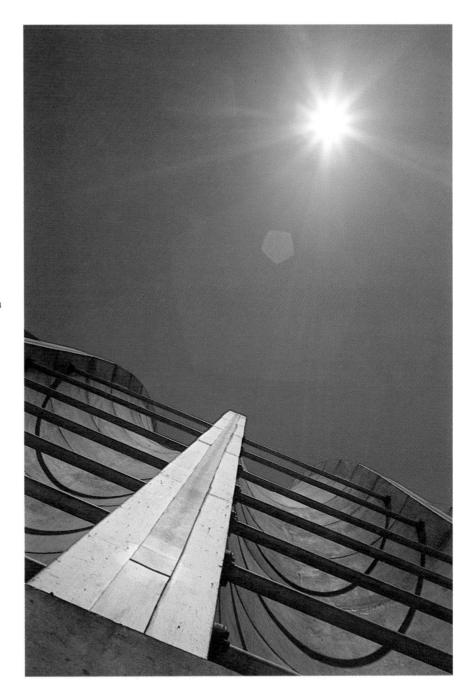

I made these photographs on my kitchen table while waiting for some cookies to bake. The picture ingredients were two measuring cups (one containing cranberry juice, the other, blue water-soluble fertilizer for my geraniums) and sunlight. My tools were a camera, a 100mm macro lens, and a tripod - no filters or coloured lights. The rich primary colours reminded me of an elegant bar or a discotheque, so I kept moving the cups, and changing focus and depth of field until the combination of shapes and colours seemed to express an appropriate mood.

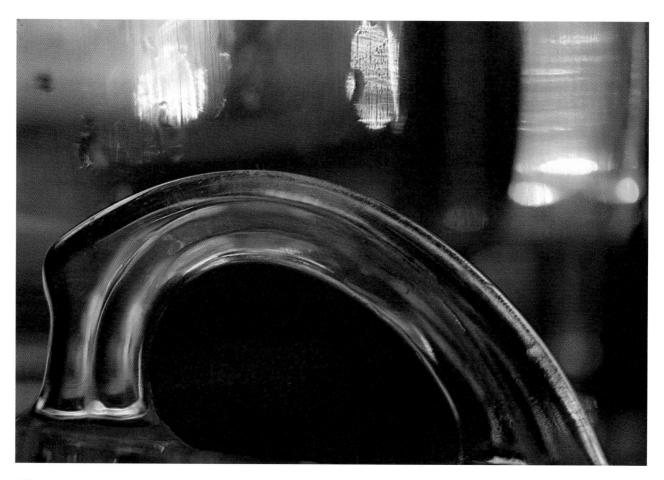

As the sunlight shone through the two measuring cups (one placed behind the other), brilliant red light and hints of blue streamed across the surface of the kitchen table, accentuating the grain of the wood. To me the situation expressed vitality and strength. I changed my camera position until the light crossed the picture obliquely; this direction seemed to accentuate the dynamic hues and reinforce the sense of vitality. I made many other compositions with the two cups, and managed not to burn a single cookie. So, if you don't have much time to make photographs, take advantage of moments like this.

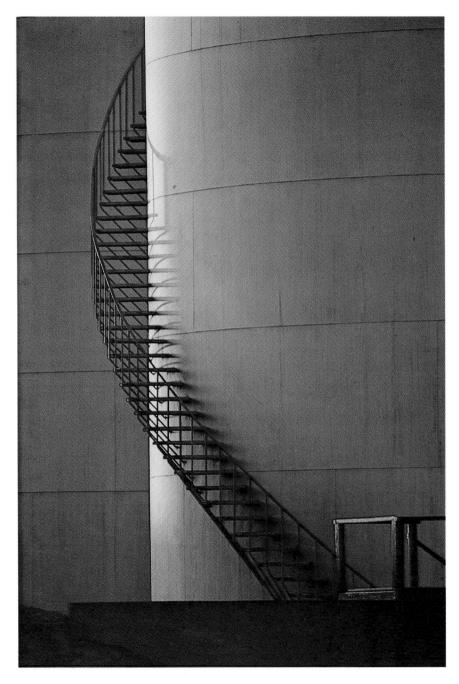

The side lighting at sunset produced a long, golden vertical line which functions as the major motif in this photograph; but it also highlighted a short horizontal line which acts as a foil or secondary motif. Connecting these two primary visual elements (which are of about the same hue and tone) is the dark, curving line of the stairs. In a situation like this, the meter reading should be made off the highlights in order to be sure they are properly exposed. However, if this is impossible, make a reading of the overall scene, and then underexpose one to two stops to ensure the dark areas remain dark.

The light on the patio and the dark shadow on the hills beyond produced a contrast so strong that a mood of unreality and unease pervaded the scene. The mood is strengthened by the absence of humans and human activity. Even the blood-red flowers tumbling to the patio seem to add to the atmosphere of foreboding. Moments like this are usually brief, so a photographer may have to work at top speed in order to compose the picture, calculate exposure, and shoot before the lighting changes. This ability comes only with practice.

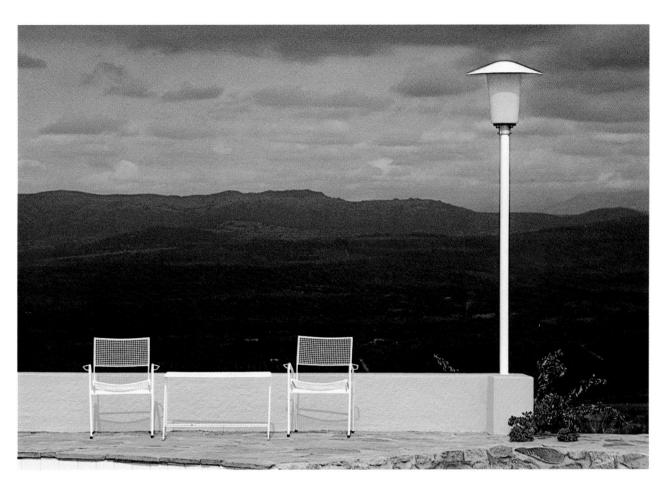

This picture is basically six horizontal bars stacked one on top of another, the darkest and heaviest one being on the bottom. Perspective is established primarily by the second dark bar (a row of trees) which is narrower than the first, and is therefore perceived to be farther away. The pattern could be made simpler by reducing the number of bars, but since both areas of dark tone are important, greater simplicity in this case could well have destroyed the sense of perspective. The hues — soft mauve, peach, orange, and blue — play a double role here. They establish the horizontal axis of design while creating a soft, delicate mood. Touching the emotions through design and colour — isn't that what all our photographs should do?

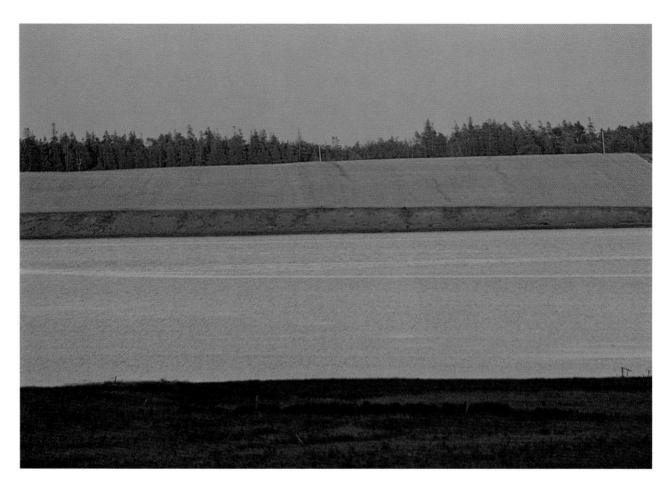

Photography and the art of seeing

Most situations – even ones that may appear unpromising at first glance – offer photographers a great variety of opportunities for making fine images. A photographer must begin by becoming sensitive to the essence of the subject matter through careful observation. Then he decides which themes are expressed through the situation or event, such as loneliness or eeriness, and selects the details that best express the theme he chooses to illustrate. An appreciation of natural design and a knowledge of the principles of visual design will play a major part in his selection of subject matter and the success and impact of the final image.

When I'm faced with a new situation, I often begin by photographing the overall view, without trying to capture the theme or subject. Then I follow it up with a series of photographs that reveal what I have discovered about the subject matter. Whether or not the resulting images are successful is only partly for me to decide. When you look at my photographs, you may not see what I was trying to convey – because our experiences differ and we respond differently to any given situation. However, even if you do see what I was trying to convey, you might have achieved more effective expression through a different composition or technique.

On the next page is a photograph of a gravel pit near my home. The gravel pit is very familiar to me, yet I still find it challenging and exciting to photograph there. As I do in many new situations, I made an overall shot of the subject matter before beginning to zero in on smaller areas – those with specific themes.

For me, the quarry is a lonely and haunting place. It makes me feel as if I am far away from civilization, perhaps on the moon. The barren, desert-like quality of the pit is caused not only by the lack of vegetation, but also by the general absence of colour and scale. Only at dawn or

sunset does the grey-brown gravel glow with warmth, and only when an occasional weed stands out against a sand bank does my sensation of height seem to be accurate. Time oftens seems to drift. I could be living at some time long past, or, perhaps, far in the future. I feel like a dreamer wandering through an existence whose limits are not clearly defined. Who am I? What am I doing here? Where am I going? These are the questions that occur to me.

When I photograph in the gravel pit, I don't try to answer these questions or alter the feeling of the place. Instead, I endeavour to observe and to photograph the visual elements that give rise to my questions and my feelings. For example, I may avoid the few plants that give an accurate impression of height, and photograph tiny erosion formations in ways that make them look like towering cliffs. I will probably go to the quarry at noon when the light is harsh, rather than at sunset, when the warm hues seem to destroy the impression of loneliness.

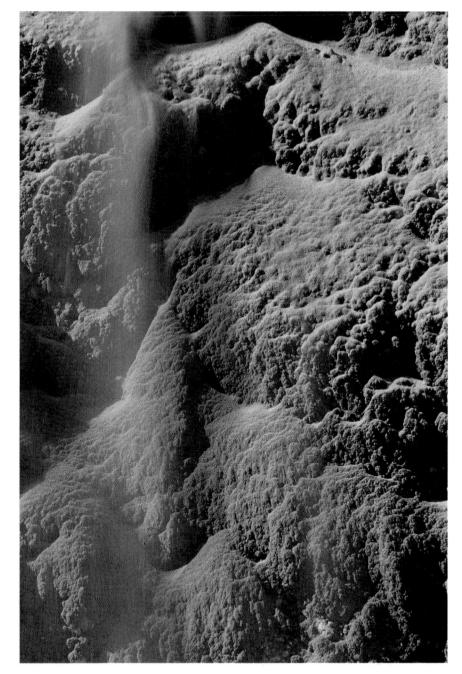

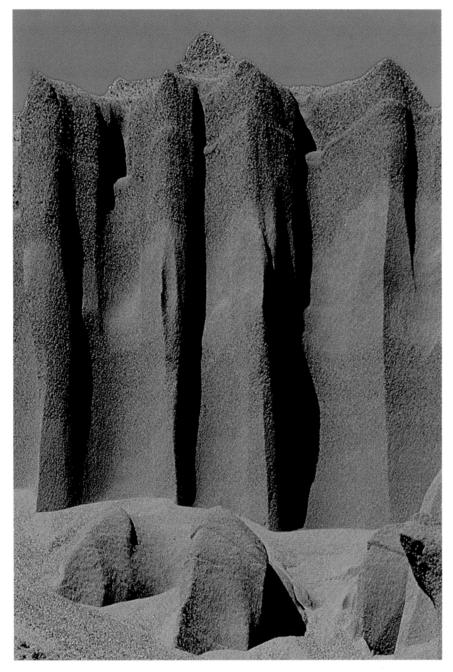

Often the strong contrast of tones at midday creates powerful shapes. These shapes have an elemental quality; they are bold, forceful, and dramatic. As I study them, I try to decide which camera position and lens will show them most effectively. Should I use a telephoto lens and move back in order to strengthen the shapes by reducing perspective? Will underexposure, to deepen the blacks, add to the sensation of strength and boldness?

In this way I am choosing tools and techniques that will help me to express photographically what the gravel pit expresses through its shapes, lines, textures, and so on. I'm selecting a small portion of the subject matter for each image, but I'm always endeavouring to be faithful to what the whole subject matter or situation expresses. This is the challenge of seeing, and photography.

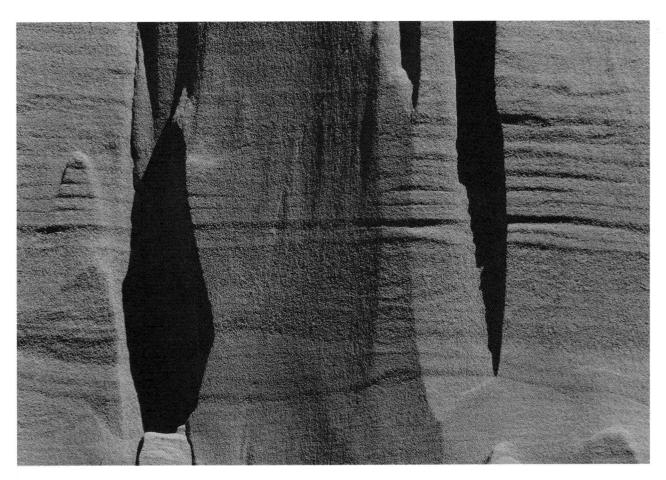

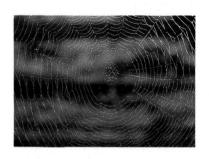

In their own way, spiders' webs excite me just as much as do gravel pits. In the chapter, "Thinking sideways," I described how I learned to abandon preconceptions and try new approaches and techniques — and finally photographed webs the way I feel about them. On this page is an

image of a spider's web that is typical of those I made for years. On the following pages are three more photographs, all of which express more adequately the magic of webs that I actually feel.

As different as the web pictures are from those made in the gravel pit, you will notice some basic similarities. These include minimal colour and an emphasis on tones. In the quarry pictures the black tones often function as accent points or lines that give order to the compositions. With the web photographs, the highlights do the same thing. While the dark tones are more important in the first series and the light tones more important in the second, tone, rather than colour, is what I usually depend on when I'm organizing subject matter.

The muted colours and the very limited range of hues in both series are also characteristic of my photographs. While I include bright, saturated hues when I feel they are important to what is being expressed, my usual preference is for restrained colours, and for one colour rather than many. However, I like to work with several variations of a single hue in a composition. These tendencies or choices, and others that are repeated again and again in my photographs, constitute my style. They occur when I'm acutely aware of what I'm doing and even when I'm not, and they say something about me.

The camera always points both ways. In expressing the subject, you also express yourself. While the choice of subject matter and adherence to the principles of visual design are important to every photographer from the photo-journalist to the naturalist, each photographer will choose different subject matter and use the principles of design in his own way. This is how it should be. When you observe your subject matter carefully, you will find yourself caring about it, and through it expressing yourself quite naturally.

If you observe your subject matter with care, respect the principles of visual design, and learn the basic photographic skills, you are well on your way to expressing your subject and yourself effectively. As you endeavour to express photographically the reality of other people and things, you will become more aware of the world around you. You will appreciate what's good in familiar things and situations, and will have the flexibility to experiment with new points of view in any situation. We need both the stability of the traditional and the challenge of the new — in order to cultivate order and tension in our photography. That is the art of seeing.

Acknowledgements

My life as a photographer and teacher of photography has been enriched by the interest and kindness of several people, many of whom may be unaware of their contribution to this book.

Dr. Helen Manzer first made me aware that good composition is vital to visual expression, and taught me discipline. Dennis Mills and Keith Scott, through their appreciation of excellence in visual design, helped me develop mine. Members of the Toronto Guild for Colour Photography and hundreds of other amateurs who love making pictures, have shared their knowledge with me and inspired me with their enthusiasm and their photographs. Many of my students, especially beginning photographers with refreshing new ideas, asked questions or made chance comments which started me along whole new ways of thinking and seeing.

I am especially grateful to Mary Ferguson, Kay McGregor, Dr. Richard Saunders, and other photographers for encouraging me to write, and to Michael Clugston, Bill Haney, Mary Ferguson, Betty Mackenzie, and Andrew Danson for their specific suggestions about this book. A very special thank you to my editor, Susan Kiil, whose professional attitude, caring, and good humour made writing a pleasure. Also, my appreciation to the many good people at Van Nostrand Reinhold in Toronto.

I also wish to acknowledge the contribution of several authors. Rudolf Arnheim's Art and Visual Perception has been an invaluable source of information and guidance. "Thinking sideways" was a way of visual thinking and teaching I had developed before discovering Edward de Bono's The Use of Lateral Thinking, but his book helped to clarify my methods. Robert McKim's discussion of visual thinking, in Experiences in Visual Thinking, was most helpful. His term "relaxed attention" made me think of "relaxed attentiveness," a good description for a way of preparing to see which I had been trying to name. Frederick Franck, in The Zen of Seeing, provided the most important ingredient of all — inspiration. Also, the dozens of photographers who wrote me their reactions and ideas after the publication of my first book, Photography for the joy of it, have all contributed to this one.

Freeman Patterson's interest in photography began in childhood, even though he was twenty before he could afford his first camera. That was in 1958. Since that time his involvement with photography has grown steadily.

Freeman was born at Long Reach, New Brunswick, graduated with a B.A. in philosophy from Acadia University in Nova Scotia in 1959, and received a master's degree in divinity from Union Theological Seminary at Columbia University in New York in 1962. The title of his master's thesis was "Still Photography As a Medium of Religious Expression." During his three years in New York he studied photography with Dr. Helen Manzer.

In 1965 after teaching religious studies for three years at Alberta College in Edmonton, Freeman resigned his teaching position to devote full time to photography. Since 1965 his photographs have been published in numerous books, magazines, journals, newspapers and advertisements, and have been exhibited around the world. Many of his photographs were selected for the National Film Board's three award-winning books, Canada: A Year of the Land, Canada, and Between Friends/Entre Amis. He is the author of two other best-selling books, Photography for the joy of it and Photography of natural things.

Freeman has given innumerable slide presentations, lectures, and workshops to both amateur and professional groups in Canada, the United States, and southern Africa. He is a past president of the Toronto Guild of Colour Photography, and for ten years was the editor of *Camera Canada*, a magazine published by the National Association for Photographic Art.

In 1967 Freeman was awarded the National Film Board of Canada Gold Medal for Photographic Excellence, one of the first two photographers to receive the award. In 1971 he was honoured with an Associateship in the Photographic Society of America for his contribution to amateur photography at the individual, national, and international levels. In 1975 he received the highest award (Hon. EFIAP) of the Fédération Internationale de l'Art Photographique (Berne, Switzerland), an honour restricted to 200 living persons and was elected to the Royal Canadian Academy of Art. In 1976 he became a Fellow of the Photographic Society of southern Africa. In 1980 he became a Fellow of the Photographic Society of America for his writing and lecturing about photography, and received a Doctorate of Letters from the University of New Brunswick.